MORE SOMERSET
Tales

Shocking & Surprising

JACK WILLIAM SWEET

AMBERLEY

'The only thing certain is that nothing is certain.'
Pliny the Elder, Natural History

First published 2017

Amberley Publishing, The Hill, Stroud
Gloucestershire GL5 4EP

www.amberley-books.com

British Library Cataloguing in Publication Data.
A catalogue record for this book is available from the British Library.

ISBN 978 1 4456 6451 4 (print)
ISBN 978 1 4456 6452 1 (ebook)

Origination by Amberley Publishing.
Printed in Great Britain.

Contents

Introduction

Somerset Ways, a guidebook published by the Great Western Railway in the first decade of the last century, declares that:

Somerset is Home
For it is here in Somerset that the longest journeys end, and the greatest wanderers come to rest at last. The land of peace and stillness.
There is no call of homing like that which comes from the land 'twixt Mendip and the Western Sea'. For this country, above all others, has kept the spirit men call homeliness, the spirit of warmth and welcoming. Not a cottage in the whole of the great span but invites the wanderer in, nor a rick nor hedge for the roofless ones but seems kindlier than the shelters of other lands.
Three things one finds here: an oldness, a kindness, and a wisdom: things in part of the countryside, in part in the dwellers in it. Things most plain to see in the slow West Country courtesy, the natural gentleness which seems a heritage of all those born in sight of Glastons Tor. Kind folk they are, with the kindest accent of any of our race. One feels that the folk here do not change; to-day they are the same at heart as when they, of all England gave Alfred shelter, not because he was King, though they were loyal people, but because he was homeless and alone.

But my stories that follow tell of another Somerset to be found beneath that of 'the land twixt Mendip and the Western Sea' – stories often shocking, surprising and sometimes rather strange.

Beneath this peaceful Somerset scene lurked shocking, surprising and strange events.

A Great Escape

Mr Justice Patteson looked hard at the four men standing before him at the Somerset Assizes on 31 March 1835 and delivered his sentence – Transportation for Life. Fifty-nine-year-old David Rose, his son James, Charles Lewis and Charles Lucas – otherwise known as the Rose Gang – had been found guilty of breaking into the shop of Mr William Young, jeweller and silversmith of the city of Bath, and stealing thirty-four gold watches, seventy pairs of gold earnings as well as a 'quantity of plate and other property'.

In passing sentence the learned judge observed that it was his duty to inflict upon them the heaviest penalty of the law in consequence of their being 'well known as belonging to a gang of thieves that had infested the City of Bath for some time and conducted their robberies in the most audacious manner'.

The verdict delivered, the four were taken to Ilchester Gaol, where they would be held pending removal to a convict ship at Portsmouth and transportation to Australia.

Together with eight other convicts, David Rose was taken to the prison hulk *Leviathan* at Portsmouth on 11 May, and two months later on 22 July he began the long voyage to New South Wales on a convict ship.

On Monday 18 May, James Rose, Charles Lewis and Charles Lucas, in company with eleven heavily manacled fellow convicts, were crowded into a prison van and set out for Portsmouth accompanied by Mr Hardy the Keeper of Ilchester Gaol, his son and two guards. As they approached Redbridge, near Southampton, one of the guards, much to his alarm, saw six of the convicts suddenly appear on the road behind the prison van and make off across the adjoining fields – minus their cast-iron leg manacles. However, Mr Hardy and his men reacted quickly and within minutes three of the fugitives were recaptured, but Rose, Lewis and Lucas were gone.

To the surprise of Mr Hardy it was discovered that six sets of manacles had been cut off and a hole sawn in the thick wooden floor of the prison van, through which the six had dropped. The escape caused a sensation, and more so when it became known that on a previous occasion James Rose had escaped from the custody of the London Bow Street gaoler when he was being conveyed in a coach to Tothill Fields Prison.

There were strong suspicions that the escape had been pre-planned as it appeared that the manacles had been partially sawn through in the prison. Several small watch saws were found in the prison van, but they were too small to have completely cut through the cast iron of the manacles and the thick wooden floor. Reporting on the 'Extraordinary and Daring Escape of Convicts' on 23 May, the *Leamington Spa Courier* commented: 'It is suspected that the irons had been partially sawn off whilst in prison, and the instruments must have been by some means conveyed to them for the purpose and also to effect their escape from the van.'

The record remains silent of the fate of the three who got away and whether they escaped transportation, but at least James Rose was still at large twelve months later when, on 9 April 1836, the *West Kent Guardian* announced that: 'One hundred guineas Reward has been offered for the apprehension of James Rose, a member of the swell mob who escaped from the Keeper of Ilchester Gaol whilst conveying

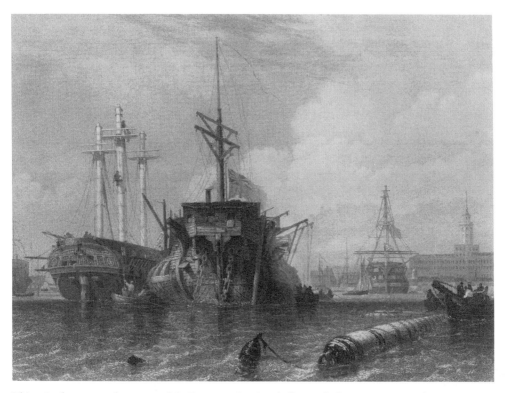

This print from 1842 shows one of the Portsmouth prison hulks in which prisoners awaited transportation to Australia.

him on board the Hulks at Portsmouth.' Likewise, the *Sussex Advertiser* carried the announcement on 11 April.

The escape was investigated by a committee of the county justices, who reported to the Somerset Mid-Summer Quarter Sessions that Mr Hardy, the Keeper of Ilchester Gaol, had been fined £200 – half his year's salary – and 'earnestly admonished to be more vigilant in future'.

The Great Storm of 1903

During Thursday evening and overnight on 10 September 1903, a 'westerly gale of unusual severity' swept across the southern counties bringing down trees, telephone and telegraph cables, blowing off roofs, demolishing buildings and causing wide-scale disruption on land and at sea. The wind, reported to have reached near hurricane force, raged up the Bristol Channel pushing before it huge waves on the rising tide.

The old pier at Minehead gave the harbour some protection from westerly gales, and the paddle steamer *Britannia* sailing from Ilfracombe to Bristol during the late afternoon was in time to disembark and take up passengers without too much difficulty at the new pier, which opened some two years before in 1901.

As the storm increased in ferocity, huge waves broke over the two piers but, despite the pounding, both survived undamaged. However, along the Esplanade, great quantities of shingle were thrown up, shelters were wrecked and bathing machines smashed to matchwood. Trees were uprooted around the town, a house in Bampton Street was badly damaged and Quay Street was flooded.

Seven miles up the coast, Watchet suffered the full force of the storm. In December 1900, a violent gale had severely damaged both the west and east piers and the reinstatement work was well in hand when the storm struck. Within a few hours half of the eastern pier and wharf, including part of the reinstated section, was torn away by the waves. One of the two steam cranes on the wharf was washed into the harbour and completely wrecked, and the second was suspended over a gap in the in the wall where the filling had been torn out. The ketch *Eastern*, partly loaded with 300 sacks of flour, was wrecked when part of the wharf collapsed on it. The westerly pier was breached and those boats not hauled ashore were smashed. A fishing smack was washed out of the harbour and wrecked a couple of miles along the coast; fortunately there was no one on board.

At Burnham, the *Bath Chronicle* reported: 'A huge tidal wave, which seemed as high as the houses on the sea front, dashed over the town, and in a few moments, floods of water were pouring down the streets. Floating on the waters were parts of bathing machines, flooring from the shelters, huge steps and even public seats which had been fastened down into the promenade.' Houses behind the seafront and in the main streets were flooded, and it was not until after midnight that the thoroughfares became passable.

The *Bath Chronicle* reported: 'Never before has a gale played such dire havoc at Weston-super-Mare.' Huge waves crashed over the seafront, damaging the Grand Parade, hurtling boats onto the road and sending water flooding into the streets, with the *Chronicle* commenting: 'Nothing seemed capable of stopping the landward march of the waves and soon all the low-lying thoroughfares of the town were flooded. That was not exactly a new experience but never before had the sea encroached so far, at least, never since any reclamation works were commenced on the foreshore.' The seaward end of the Birnbeck Pier was wrecked and carried away and the pier pavilion, amusements and funfair were badly damaged. Over

1,000 people, some of whom had gathered for an entertainment in the Knightstone Pavilion and others at the swimming club's annual gala in the Knightstone Baths, became stranded when the sea swept over the causeway linking the island to the town. To add to their discomfort and concern, the electric lights failed. However, the Pavilion escaped with little damage, but the boiler house of the swimming baths and the retaining wall of the ladies' baths were wrecked. It was not until the tide receded that the people stranded at Knightstone could make their way back along the badly damaged causeway, now reduced in places to half its original width. One commentator suggested that 'with a little more battering from the waves, Knightstone would have again become an island'.

The only reported fatality along the Somerset coast was at Weston-super-Mare. Mr Edgar Bryant, an ironmonger and a Knightstone electrician, had left home at the height of the storm to go to the Pavilion to repair the failed lighting but failed to return. All efforts to find him were unsuccessful until 26 September, when his body was found on the beach near the village of Freshwater East, Pembrokeshire. At the following inquest it was suggested that Edgar Bryant may have fallen into the gap in the causeway opened up by the waves and been washed out to sea. A verdict of death by drowning was returned.

Just up the coast, Clevedon was battered by enormous waves that broke over the Lower Esplanade. Bathing machines were smashed to pieces, boats washed away, and decking of Clevedon Pier badly damaged. Spray extinguished all the gas streetlamps on the Esplanade, and the stout railings were snapped off. The front walls and railing of the houses on the seafront were demolished and the seaward walls of the basement

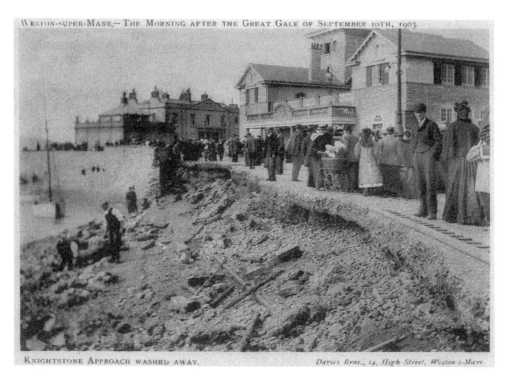

WESTON-SUPER-MARE.—THE MORNING AFTER THE GREAT GALE OF SEPTEMBER 10TH, 1903.

KNIGHTSTONE APPROACH WASHED AWAY. *Davies Bros., 14, High Street, Weston-s-Mare*

Local people inspect the damage to the Knightstone causeway.

of the Pier Hotel were either washed away or driven into the lower rooms, filling them with debris. At the Green Beach and Little Harp Bay huge waves swept away seats, ornamental railings and flower beds from the Esplanade, but the bandstand built in 1887 survived undamaged. Fairfield and Salthouse Fields were flooded when part of the protecting sea wall was breached.

The next morning, the sun shone from a clear blue sky, the sea calmed and residents along the Somerset coast emerged to survey the damage and set about getting back to normal.

Poor Betty Trump

The first impression of the parish church of Buckland St Mary is its size and how it dominates the small remote village high in the Blackdown Hills on the Somerset and Devonshire border. The village is a tranquil place but the quiet churchyard holds a tale of a terrible event.

In February 1823 the area was in uproar: a killer was on the loose and the hunt was on for the killer, or killers, who had butchered thirteen-year-old Betty Trump. Betty had gone to visit a sister in Winsham, near Chard, but had failed to return home to Buckland St Mary. After several days of searching, her small body was found in Coppice Burrows, around 50 yards from the Taunton–Chard turnpike road and about half a mile from her home. Betty's throat had been cut, but her clothing appeared to be intact and there was no sign of a struggle; a basket she had been carrying was set down undisturbed by her side.

The hue and cry was on and every stranger passing through the Blackdown Hills was a suspect. So angry were the local people that a reward of £100, equal to five years wages for an agricultural labourer, was offered for the apprehension and conviction of the murderer. The local gentry formed a committee to organise the hunt, and Mr Samuel Hercules Taunton, a Bow Street Runner, was brought in to lead the investigation. Quite soon a local labourer, William Flood, became the prime suspect and was brought before Revd Doctor Palmer, one of the local magistrates who, after questioning him, decided that he was innocent and the suspect was released. However, the committee of investigation were not prepared to accept the Revd Doctor's decision and William Flood was rearrested and lodged in a small room at the Green Dragon Inn at Combe St Nicholas. He was examined by other local magistrates, but despite his protests of innocence and strong evidence that he was at his employer's house with witnesses at the time the murder was supposed to have occurred, William Flood was sent for trial at the Somerset Summer Assizes and charged with the murder of Betty Trump. It was during this time that members of the committee of investigation indulged in several rather unusual methods to seek to establish his guilt.

On one occasion, Phillip Wyatt, a well-known character known as the 'Carpenter, Poet and Soothsayer of the Western Parts of Somerset', was taken to William Flood's room accompanied by a Captain Bennett, one of the committee of investigation, and a strange conversation took place. The soothsayer told the prisoner that he had lain three nights on Betty Trump's grave and on the third night her spirit appeared and had walked with him to the spot where the body had been found, conversing with him all the way with respect to the murder. The spirit had accused William Flood of committing the murder and, after hovering over the spot where the body had lain, the spirit vanished. Phillip Wyatt took the prisoner's hand and, holding it aloft, declared that 'This is the hand of a murderer, as Nathan said unto David, so I say unto thee, thou art the man!' And with that, both soothsay and Captain Bennett left the room.

Another unusual method of seeking to establish guilt was widely practised during the weeks William Flood lay incarcerated in the Green Dragon. A bible was opened and the front door key of the inquirer's house was placed upon the sixteenth verse of the first chapter of the Book of Ruth, which reads, 'And Ruth said entreat me not to

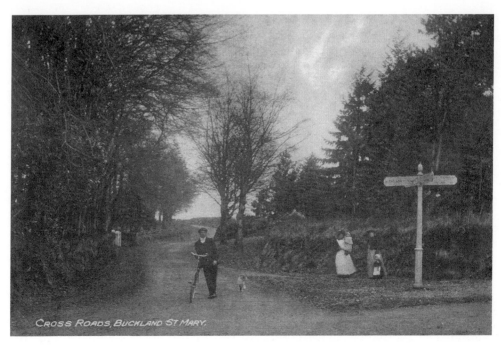

The body of Betty Trump was found not far from these crossroads.

leave thee or to return from following after thee: for whither thou goest, I will go and where thou lodgest I will lodge: thy people shall be my people and thy God, my God.' The bible was then closed and tightly bound, with the bow of the key left protruding. Two people would then hold the key between their forefingers and chant 'Did William Flood commit the murder?' followed by the verse. If the bible turned fully round before the verse was repeated, William Flood was judged guilty; if not he was innocent. It was said that the members of the committee indulged in this practice and the bible of the landlord of the Green Dragon was worn out at verse 16!

William Flood languished in Ilchester Gaol until 11 August 1823 but when he was brought before the Grand Jury at the assizes in Bridgwater, they decided that the evidence was not strong enough to establish his guilt of the murder of Betty Trump and he was set free. The murderer was never caught but suspicion continued to fall on William Flood who, shortly after his release, went to live with a widowed sister at Low Ham, near Langport. In 1835 on his deathbed, William Flood gave a sworn statement that he was entirely innocent of the murder of Betty Trump. He is buried in the churchyard of High Ham Parish Church.

Meanwhile, in the churchyard of St Mary's, a weathered gravestone in the shade of an ancient tree marks the final resting of poor Betty and bears the following fading inscription:

Sacred to the memory
of
Betty Trump who at the early age of 13
was cruelly murdered by an unknown hand
*The 20*th *February 1823*

Fatal Water Attractions

A hot summer's day, and what better way to cool down than a paddle or swim in a cool, clear river. An attractive proposition or a fatal attraction? For a young Londoner living in Somerset, the attraction would prove fatal.

Nineteen-year-old Albert Demer had come down to Charlton Adam from his East London home in early April 1895 to lodge with Mr Alfred Slade, a member of the Salvation Army, and help him with the sale of *The War Cry*, tea, and matches made by the army. Albert was a friendly young man and during the summer of 1895 became a well-known figure in the villages around Charlton Adam. Once a week he visited Baltonsborough to sell *The War Cry*, along with the tea and matches. On Thursday 22 August, after leaving Albert to carry out his regular visits, Mr Slade travelled down to Bridport to bear witness with fellow Salvationists in the town; he would not see Albert alive again.

At around three o'clock on that Thursday afternoon, Albert Demer called at the house of Mrs Sarah Buckle at Baltonsborough with her regular copy of *The War Cry* and, after passing a few minutes in conversation, Albert walked off along the bank of the nearby River Brue in the direction of Flight's Pool. Mrs Sarah Buckle would be the last person to see the Salvationist alive.

Later that afternoon Mrs Dawes was walking beside the River Brue and at Flight's Pool, she espied a pile of men's clothing, a bag and a small dog standing guard, but of the owner there was no sign. Feeling a little concerned, she walked on and when she met Bertie Dunkerton around half a mile further along, she told him about the unattended clothing and he went to investigate. On his arrival at Flight's Pool, and finding the place deserted but the clothing and the dog still there, Bertie reported the mystery to PC Cook, the local police officer, who went to investigate. An inspection of the contents of the bag revealed a pedlar's certificate in the name of Albert Demer of Charlton Adam, a notebook with details of Albert's rounds, several quarter-pound packets of tea, boxes of matches and a pricelist of Salvation Army 'Stores'. There was a purse containing 21s in silver and 1s 2d in copper coins. PC Cook made a thorough search of the riverbank but, finding no sign of the owner of the articles, feared the worse – in the failing light of that late August evening, Flight's Pool looked dark, deep and dangerous.

PC Cook cycled to Somerton, reported the matter to Superintendent Perry, and then proceeded to Charlton Adam, where his enquiries established that the missing man lodged with Mr Alfred Slade, who was absent at Bridport. Early the following morning PC Cook, accompanied by John Bottle and Thomas Say from Barton St David, set about dragging the river and retrieved the body of Albert Demer from Flight's Pool. An examination of the corpse revealed marks on the right elbow, on the muscle of the left arm and on the head as if Albert had struggled in the water.

Thirty or so miles away on the Friday morning at Bridport, Mr Alfred Slade received a postcard from Albert that had been posted at Baltonsborough the previous day. It said that he would bring down the articles the Salvationist had requested, but shortly afterwards a telegram arrived from PC Cook stating that Albert had been found dead.

The inquest into the death of Albert Demer was held in the Greyhound Inn, Baltonsborough, on Saturday 24 August. Formal identification was given by Albert's

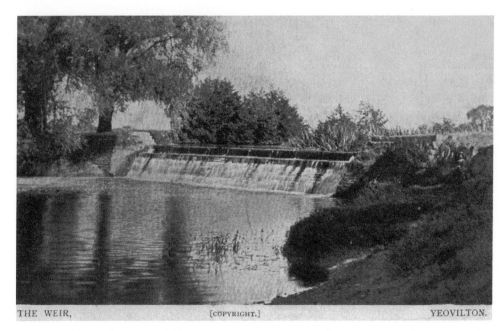

THE WEIR, [COPYRIGHT.] YEOVILTON.

Father Boothby tried unsuccessfully to save Joseph Gapper from drowning in Yeovilton Weir Pool.

father, who had travelled down from London overnight. Following evidence from several witnesses and a statement from Mr Alfred Slade that the young man could not swim and did not drink intoxicating liquor, the coroner stated that the evidence clearly pointed to an accidental drowning. The deceased was apparently on his way home and, Thursday being a very hot day, had been tempted to bathe but, not being able to swim and not knowing the depth of the water, the poor lad had immediately drowned; the coroner said this was the only sensible conclusion. The inquest jury returned a verdict of 'Found drowned in Flight's Pool in the River Brue'.

Father Boothby, the assistant priest at St Michael and All Angel's Church in Yeovil, was cycling back from Glastonbury during the very warm evening of bank holiday Monday 2 August 1926, and had decided to return via Yeovilton. As he passed Yeovilton Weir, he was horrified to see a swimmer struggle for a moment and then disappear under the surface. Leaping from his cycle, Father Boothby stripped off his clothes, ran down the bank and dived into the pool. Sadly his repeated efforts to find the missing swimmer were in vain, and he was forced to give up the search.

The missing man, forty-two-year-old labourer Joseph Gapper, whose wife was sitting on the bank and witnessed the whole terrifying event, had been swimming in the pool for around ten minutes before he suddenly disappeared. The alarm was raised and a team of local men began to drag the pool and the river downstream, but it was not until the following morning that Joseph's body was recovered. An examination of the corpse found no sign of injury and the deceased was believed to have been in the best of health.

At the following inquest it was confirmed that the medical examination verified death by drowning and the verdict was returned that Joseph Gapper had accidently drowned.

Random Tales

A Big Bang

In the 3 January 1868 edition of the *Western Flying Post*, there were complaints to the manager of the Yeovil Gas Works about a strong smell of gas in Wine Street. Two workmen, Messrs Budgell and Munford, were sent to deal with the problem and, on locating the possible source of the gas leak, began to dig up the street. Unknown to the diggers, a sewer had been laid alongside the gas main, and suddenly Mr Budgell's spade broke into the sewer pipe. There was a massive escape of inflammable sewer gas and, as Mr Budgell struck a match to see what had happened, the sewer exploded, blowing out parts of the floors and yards occupied by Mr Holland, Mr Childs and Sgt Holwell and sink traps in other neighbouring houses. Fortunately there were no casualties apart from two very surprised workmen who would no doubt exercise more caution while searching for smells.

Beware of Stoats

One dictionary definition of a stoat is that it is 'a small brown North European mammal related to the weasel', a deadly enemy of rabbits and, it seems, occasionally to humans as well.

Such an event took place in 1908 at Nynehead, near Wellington, and on 10 October of that year, *Pulman's Weekly News* wrote that a young lady was wheeling her bicycle through the gate of the Nynehead Rectory in broad daylight when, to her great surprise,

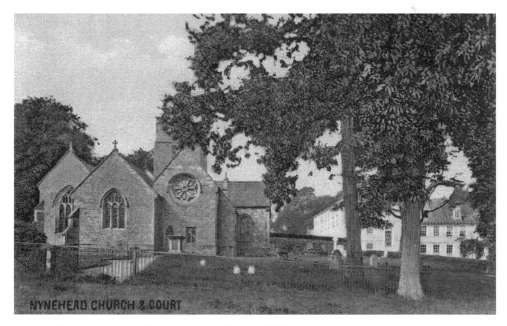

A young lady was attacked by a stoat near Nynehead Church in 1908.

a stoat jumped out and attacked her. The young lady knocked the animal down, kicked it away and, in somewhat of a panic, rode off as fast as she could peddle. Looking back, she was amazed to see the stoat running after her but soon outpaced the furious animal as she was riding downhill.

There was a cottage at the bottom of the hill and the housewife working in the kitchen was alarmed to hear her young four-year-old son screaming from the front garden. Rushing out, she was horrified to see him being savagely attacked by a stoat, which she knocked away but not before the little lad had suffered a badly bitten thumb. The stoat immediately turned and attacked the mother, who retreated with her son into the cottage, followed by the enraged animal, which she managed to shut up in one of the rooms.

A local gamekeeper was called and the stoat was dispatched, with the seventy-three year-old gamekeeper commenting it was the largest he had seen and that he had never heard of stoats attacking humans.

A Suspicious-looking Box

In late February 1915 there was a minor sensation in the Chard area when it was reported that a 'suspicious looking box' was unearthed during roadworks near the Axewater Bridge, which spanned the Dorset and Somerset county boundary just outside Winsham. Recent floods had caused the road to subside and Thorncombe contractor Fred Reed and his gang were busy reinstating the carriageway.

Fred was shovelling some soil when he was surprised to turn up a small metal box of 'a suspicious character', some 5 inches long and with what appeared to be a fuse protruding from one end. Curious to see what it contained, Fred, watched by his companions, opened the box and found inside some wet powder emitting a strong acidic smell. On the outside of the mysterious object the words 'Nuremburg, Germany' could just be made out and with the fears of spies and saboteurs still engaging much of the community, the immediate thought was a bomb.

Closing the box, Fred Reed put it to one side and when work finished for the day took it home, packaged it and despatched the box to the War Office in London. (Remember, this was thought to be a bomb!). The following day, Fred went to Chard and notified Inspector Worner of the find and the action he had taken. The inspector notified the police at Beaminster, as the mysterious object had been found on the Dorset side of the bridge.

Rumours were soon circulating of German spies and saboteurs and there was much speculation that the 'bomb' had been placed to blow up the Axewater Bridge or was set to demolish the nearby mainline railway bridge and had been washed downstream in the recent floods.

However, the fears were soon put to rest when Fred Reed received a letter from the War Office stating that the mysterious object was not a bomb but probably a battery similar to those used in flashlights.

A Healthy Appetite?

A quite bizarre tale from the pages of the *Bath and Cheltenham Gazette* on Tuesday 20 May 1828:

On Saturday was committed to the Shepton-Mallet bridewell (for want of sureties), Mr Joseph Stokes, of Frome, charged with a most violent assault, the evening before, upon his own wife. This is the celebrated gentleman that frequently amuses his friends with drinking a rummer glass of boiling water, and immediately afterwards eating the whole glass!

Lighting a Pipe (Fatally)

Who would think that lighting a pipe of tobacco could prove fatal? Tragically, for a former soldier and a local farmer this simple act would cost them their lives.

Thirty-year-old Harry Goodchild, a former gunner in the Royal Artillery, was employed as a flagman to walk in front of a steam traction engine owned by Mr Heal's Travelling Circus. At around 8 a.m. on Tuesday 15 May 1894 the engine, led by Harry carrying his flag, was passing the Lime Kiln Inn on the Langport road near Long Sutton. The morning was fine and the traction engine was being driven at a steady 2 miles per hour by Mr Heal Jr. Also riding on the engine was Charlie Gay, who suddenly noticed that Harry Goodchild had stopped to light his pipe only a few feet in front of the engine and shouted to him to get out of the way. Harry appeared startled by the shout, then confused, and, to Charlie's horror, jumped into the path of the traction engine; one of the front wheels drove over the flagman's legs and a rear wheel over his left foot.

Harry Goodchild was conveyed on a farm cart to Yeovil Hospital where Dr Aldridge examined the injuries, which comprised a fractured and severely bruised right leg and a crushed left foot accompanied by a great loss of blood. An immediate operation was

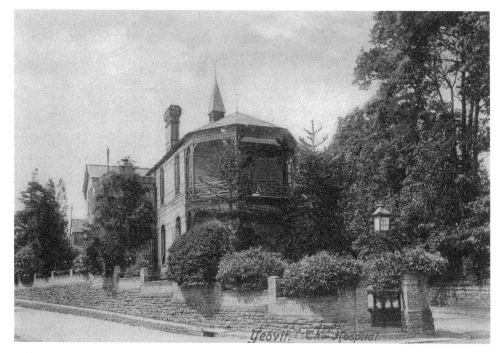

Following his accident Harry Goodchild was taken to Yeovil Hospital, where he died from shock, loss of blood and the effects of the operation.

carried out to amputate Harry's foot but sadly he died within a few days from shock, loss of blood, and the effects of the operation.

At the inquest into Harry Goodchild's death, no blame was attributed to Heal Jr, the driver of the traction engine. Mr Heal's daughter told the jury that the deceased had been employed by her father for two months and had been instructed to keep a distance of 25 yards in front of the engine. A verdict of 'accidental death' was recorded and Harry Goodchild was buried in Yeovil Cemetery on 26 May 1894.

Mr Wilfred Keirle of Welham Farm, Charlton Mackrell, climbed up onto the horse-drawn self-binder reaping machine and sat down next to the driver, Mr Herbert Bown. The afternoon of Saturday 25 May 1917 was warm and the reaping had gone well in the oat field by Charlton Lane. The farmer had been shooting rabbits as they ran to escape the reaping machine and, having taken a reasonable bag, he decided to ride back to his farm. Herbert Bown started the horses and set off down the lane. Farmer Keirle placed his double-barrelled shotgun on the bed of the machine holding the barrels between his legs and resting the muzzles against his stomach as he lit his pipe. Suddenly there was a crash as the shotgun went off and the contents of one barrel of shot tore into Wilfred Keirle's abdomen. The noise startled the two horses but before Herbert Bown could render assistance to his employer, he had to fight to bring them under control. With the help of Mr Herbert Crossman, one of Mr Keirle's cowmen who had been helping with the reaping, the terribly injured farmer was laid in the shade at the side of the lane and Dr Ingle was sent for from Somerton.

On receiving the message Dr Ingle set out for Charlton Mackrell; some twenty minutes later he reached the scene and found the farmer curled up on the grass bank. The doctor packed the gaping wound and Farmer Keirle was conveyed home to Welham Farm but, despite Dr Ingle's best efforts, the terrible injuries proved fatal and Mr Wilfred Keirle passed away the next morning

At the inquest that followed, the jury were informed that death was caused by haemorrhage and shock, and it was established that both barrels of the gun had been loaded and the hammers cocked. From the evidence, it was concluded that the jolting of the machine had caused one of the barrels to be fired, leading to fatal consequences.

The jury returned a verdict of 'death from shock' following injuries caused by the accidental discharge of a gun, which the deceased was carrying while riding on a reaping machine.

The Lost Aeronaut

At 6 p.m. on Monday 9 July 1849, *The Rainbow* gas balloon, owned by Mr W. Wadman, brass founder and gas fitter of Bristol, rose from Cardiff into the warm summer sky and drifted south-west towards Penarth. The pilot, or aeronaut, was Mr Richard Green, who had flown *The Rainbow* on two previous occasions from the Sydney Gardens at Bath on 28 May and 25 June, but was not an experienced flyer. Mr Wadman had planned to accompany his aeronaut but had been taken ill and was too unwell to travel.

As the balloon rose over Bute Docks, a cat in a basket was released and parachuted down to land unharmed, but no doubt terrified, on the deck of a ship.

Slowly the balloon gained height but a change in wind direction sent it south-east across the Bristol Channel in the direction of Portishead. Some two hours later, farmer John Gill watched the balloon from his house at Kewstoke, near Weston-super-Mare, rapidly descending beyond Sand Point about three-quarters of a mile away. Calling on two of his farm lads, John Gill hurried towards Sand Point to see if any help was needed. Suddenly the balloon rose up and, quickly gaining height, drifted north towards Clevedon but then changed direction, travelled south and disappeared from view in the growing dusk.

At around 2 a.m. the next morning, surgeon William Salmon of Wedmore was returning home across Godney Moor from visiting a patient when he saw in the light of the waning moon – 'a most unusual object which on approaching discovered it to be a large balloon.' The surgeon called out several men and the balloon, which was partly deflated but undamaged, was secured. An examination of the basket (or car) revealed that the ballast bags used to control the ascent and descent were almost empty. The large grappling iron and rope used to tether the balloon was in place, as was the guide line. The canvass used to rap the deflated balloon remained strapped inside the basket but of the aeronaut there was no sign, other than his coat and boots, all soaking wet.

The downed balloon had caused something of a sensation and a crowd had soon collected on the moor. The talk was that this must be *The Rainbow*, which had crossed the Bristol Channel the previous evening, but what had become of the aeronaut? It was conjectured widely in the district and in the local newspapers that the balloon had come down into the Channel near the shore and the aeronaut, being known to be a strong swimmer, had decided to swim ashore. Thus lightened, the balloon had risen to finally land on Godney Moor. It was deflated and transported to surgeon Salmon's house to await its owner.

The newspapers were soon speculating on the fate of Mr Green and, as nothing had been heard of him, the general opinion was that he had not survived the strong Channel currents. Mr Wadman travelled to Wedmore, where he inspected the balloon and the contents of the basket and confirmed that the coat and boots belonged to the missing aeronaut.

On the evening of Wednesday 17 July, farmer John Gill happened to be on the beach at Sand Bay when he saw a body floating a few yards offshore. After gathering several of his farm hands, they pulled the body ashore. In his capacity as churchwarden for the parish of Kewstoke, the farmer examined the corpse, which was that of a man

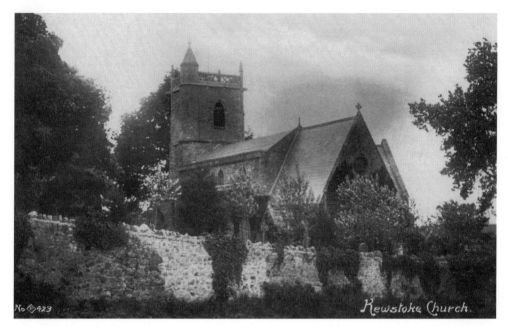

Richard Green lies in Kewstoke Churchyard.

aged between thirty and thirty-five years of age, around 5.5 feet tall with a full beard and dark brown hair. The body had neither coat nor boots, but still wore a pair of light-coloured trousers with a two buckle web belt, a pair of long underpants, socks, a white shirt with a false collar and a striped light-coloured waistcoat. A search of the trouser pockets revealed a small comb in the right and 21s in silver in the left. There was no other article found to identify the body, which, after having been in the water for some ten days, was in such an advanced state of decomposition as to render any facial recognition impossible.

The beach to which the corpse had been brought was in the parish of Kewstoke and in the case of bodies being 'at all offensive' the parish authorities had the coroner's standing permission to call some of the local farmers to view the remains and then bury them as soon as possible. Depositions of the farmers would be taken by the coroner some days later. John Gill quickly gathered several local farmers to view the decomposed body, a coffin was procured and it was buried in Kewstoke parish churchyard at 10 p.m. with the vicar, Revd Hathway, reading the burial service. The burial is recorded in the parish register of St Paul's Church on 18 July as 'Unknown. Washed up on Sand Bay. Kewstoke.'

The coroner, F. Uphill Esq., attended a few days later when it was confirmed from the evidence presented that the deceased was Richard Green, the missing aeronaut.

It was generally accepted that the inexperienced aeronaut (who had only flown over land) probably panicked when *The Rainbow* came down in the sea and after observing the beach was not too distant, removed his coat and boots and decided to swim for it. The strength of the tide and the currents had been too strong and he was swept away and drowned, becoming the first balloon fatality in the Bristol Channel.

The Fire at Mill Lane

On 30 April 1909, Clara sent a picture postcard from Yeovil to Miss B. Palmer at No. 86 Third Avenue, Gloversville, Fulton County, New York, America. She wrote: 'I thought would like to look at the ruins of the Dressing yard after the fire. This was taken from the orchard side nobody has stopped work at yet we hope they won't have to.'

Just one week before, in the early hours of the morning on Friday 23 April 1909, fire broke out in Messers Chapman & Co.'s building and decorating premises adjoining the old Town Mill and Messrs Ewens and Johnson's leather-dressing factory at the bottom of Mill Lane, Yeovil. Frederick Masters and his family lived in a cottage next to the builders' premises, and shortly after 3 a.m. on that Friday morning Mrs Masters was woken by the roar of flames.

Fuelled by the large quantities of Chapman and Co.'s highly inflammable materials and stock, the fire was already out of control and the flames quickly spread to Messrs Ewens and Johnson's factory, where the wooden louvre ventilators burnt out and the gaps produced an updraught that turned the whole building and its stock of leather into a roaring furnace.

Meanwhile, Frederick Masters had raised the alarm and Mr Chapman, the builder, had arrived on the scene, followed shortly after by the Yeovil Voluntary Fire Brigade led by Second Officer Cridland. Messrs Ewens and Johnson had only recently installed two fire hydrants in their factory, but efforts to operate them were doomed to failure as the flames drove the would-be operators back out of the building.

The buildings, including Frederick Masters' cottage, were a mass of flames. As nothing could be done to save them, the fire brigade turned its attention to saving nearby premises, which included a house and Mr Ebenezer Pittard's leather-dressing factory and wool store. Fortunately there were three fire hydrants in the vicinity with a good supply of water at high pressure. The brigade finally contained the fire and no more buildings were damaged.

The fire finally died down and the full extent of the damage could be seen. Messrs Chapman's premises were completely burnt out and their entire stock of building and decorating materials were lost. Messrs Ewens and Johnson's factory, together with the firm's valuable stock of leather and machinery, was destroyed and only the piers of the building were left standing. Frederick Masters and his family lost everything, barely escaping with their lives, and nothing remained of their home but the walls.

The cost of the fire was estimated to be £10,000, of which £7,000 was the loss to Messrs Ewens and Johnson.

Reporting on the fire on 30 April, the *Western Gazette* wrote:

Owing to the great damage to the Mill, another of Yeovil's few remaining ancient buildings has been threatened, for it is claimed that this venerable is the successor to, and standing on the same spot, as the Saxon mill recorded in the Doomsday book as of 'ten shillings rent'. The remaining walls of the present Mill are very old indeed, and according to a tradition form part of the same building, which, although in the midst of the great fire which devastated Yeovil in the time of the Wars of the

Roses about AD 1460, and when it is said over 100 houses were destroyed, then escaped unscathed. It has not been used as a corn mill for many years, and latterly has been used for the business purposes of Mr Pittard and Messrs Chapman, the water wheel, which formerly turned the mill stones, having used to supply power for various machines. The fire smouldered amongst the ruins during the day, and in the evening it was again found necessary to get a hose to work to thoroughly damp down the ruins. Unfortunately, in addition to the damage done by the fire, great loss will be sustained by the throwing out of work of about 30 men employed in the burnt-out buildings.

The *Gazette* went on to reassure its readers that Messrs Ewens and Johnson's glove factory had not been affected by the fire and neither had the firm's business.

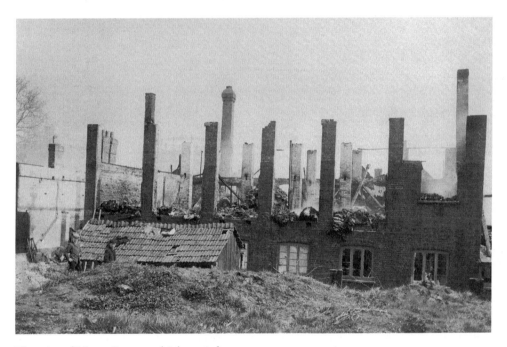

The ruins of Messrs Ewens and Johnson's factory.

Two Very Bad Lads

Instead of going to bank the £20 in notes and cash entrusted to him by his employer, Mr Knight, chemist of Wincanton, sixteen-year-old errand boy Charlie Cross appropriated it for his own use and, with fifteen-year-old Tommy Hinks, embarked upon a brief life of crime on Thursday 27 March 1879.

The pair's first stop was at Mr Frank Busby's draper's shop in Milborne Port, where Charlie bought an overcoat for 20s. When Tommy asked where he could buy a pistol, the draper directed the youths to Sherborne and an hour or so later they entered Mr Bannister's ironmonger's shop in the town (in 1879 firearms of various descriptions could be freely purchased in ironmongers' shops) and on being asked, the manager, Mr Smith, produced a number of pistols for inspection. Charlie decided upon a six-chambered revolver and bought it, no questions asked, for 41s 6d, together with fifty rounds of ammunition, a quantity of gunpowder, percussion caps and a powder flask.

Next came the purchase of a double-breasted coat for 11s 6d by Tommy at Messrs Woodward and Dorling's drapery. At Mr Hill's saddlery in Half Moon Street, Charlie bought a brass-handled whip, Tommy chose one with a bronze handle, and in addition they bought a pair of hunting spurs, all for £1 18s 6d and paid in cash. A meal of beef washed down with tea was taken at Mrs Sansome's refreshment house for 2s, plus a sixpence tip, following which the pair disappeared into the night.

Just before midnight, glove manufacturer Mr George Dyke was riding home to Milborne Port but as he approached Bowden Corner two figures emerged from the gloom and one shouted 'Stand!', followed by a flash and a bang. Mr Dyke felt a violent blow on his left thigh and, as his horse bolted in fear, he heard the crash of another shot. On arriving home, the glove manufacturer found that a bullet had gone through his thick overcoat and deflected into the lining by a folded leather strap he kept in his pocket. Luckily he was only bruised.

On Saturday, PC Devenish of Kington Magna in Dorset received a call that two youths fitting the description of the pair wanted for stealing the money from Mr Knight had been staying overnight at the Ship Inn, West Stour, and on arrival at the inn he was told that the suspects were still in bed. The constable instructed that all the outside doors be locked and then sent the landlady upstairs to tell the youths that breakfast was ready. Charlie and Tommy followed her down the stairs and straight into the arms of PC Devenish. They made no attempt to escape and the constable arrested them without a struggle. On being searched, Charlie was found to be in possession of a cashbook, a £5 note, a purse containing £2 5s 3d in gold and silver, two American coins, a six-chambered revolver (recently fired), twenty-six rounds of ammunition, a pair of spurs, a whistle, a black mask and false moustache, a cigar holder with three cigars, two pocket knives and a watch. PC Devenish was even more surprised when Tommy was found to be in possession of two loaded pistols (one of which had been fired) a powder flask, some bullets and percussion caps, a pistol ramrod, a black mask and false moustache, a pocket knife, a purse with £1 4s 6d and a rope tied around his waist. Two riding whips were recovered from the room where the two had spent the night.

On 4 April the two desperados were brought before the Wincanton magistrates and sent for trial at the spring assizes in Taunton.

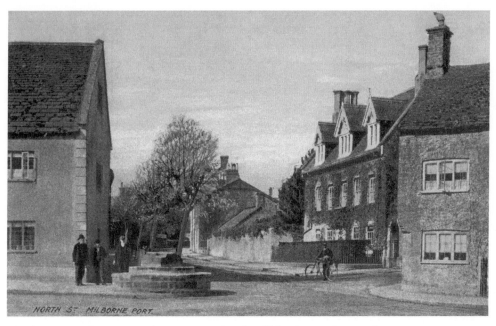

Charlie Cross and Tommy Hinks set out on their brief life of crime from Milborne Port.

Just over three weeks later on 29 April, Charlie Cross and Tommy Hinks found themselves before the judge, Baron Huddleston, at the Somerset Assizes, each charged with 'shooting with intent to steal' at Milborne Port on 27 March 1879.

The judge, in his summing-up of the evidence presented to the jury, expressed surprise at the sale of the revolver and ammunition to the youths but was told that it was not unusual to sell such weapons to farmers' sons. He pointed out that 'Stand' was a familiar phrase in the literature of the day, which did so much damage to lads who enjoyed reading about Dick Turpin and Jack Sheppard.

The jury found both prisoners guilty as charged but recommended mercy to Tommy Hinks as they considered he had been induced to go with Cross, who was older. In passing sentence, Baron Huddleston said that he had no doubt that what they did was the result of reading books about highwaymen. They had got the idea that it would be a fine thing to have whips and spurs and go around the country committing such offences. He reminded them that if they had been found guilty of shooting at Mr Dyke with intent to kill him, he would have sentenced them to penal servitude for life. Instead, he was going to give them a chance and the sentences would not be so much to punish them as to set an example to others. He believed that there was no more effective deterrent than severe and ignominious punishment, namely corporal punishment.

The judge sentenced Charlie Cross to six months' hard labour with thirteen strokes of the birch when he entered prison and another thirteen shortly before he left; Tommy Hinks was given three months and twelve strokes with the birch rod.

A number of questions have always remained unanswered: where did they spend all day Friday? Where did Tommy Hinks get two pistols (only Charlie's was ever identified)? And where were the missing twenty-four rounds of ammunition and gunpowder? History is silent.

Hanging the Nempnett Killers

The square of black fabric, called the 'black cap', was placed on the wig of Judge Lord Chief Baron Pollock, with one of the four corners pointing at the two men standing impassively in the dock at the Somerset Assizes in Taunton on Friday 4 April 1851. The jury had found John Wiles and John Smith guilty of the vicious murder of seventy-four-year-old William Wilkins and savagely beating, to within an inch of her life, his seventy-one-year-old wife Sarah in their small shop at Nempnett Thubwell during the morning of Saturday 8 February.

The two prisoners were caught within hours of the crime and found to be in possession of a loaf of bread, some tobacco and 8s 6d in the pocket torn from Sarah's dress. For these pathetically insignificant items an elderly man was killed and his wife almost beaten to death.

On passing the sentence of death, the judge addressed the men and stated that the crime was 'one of the most unprovoked, most purposeless and most cruel and sanguinary deeds that have ever disgraced the country'. The prisoners were reported by the *Taunton Courier* to have received the sentence without betraying the slightest emotion and with the most callous indifference.

Wiles and Smith were taken back to the county gaol at Wilton, Taunton, and lodged in separate cells to await their execution on Wednesday 23 April.

Readers of the *Taunton Courier* learnt that John Wiles was fifty-four years of age and had been born at Clevedon where his father was a gardener:

> He had served an apprenticeship to a blacksmith at Weston-in-Gordano, married at Portishead, and for some time carried on his business of smith at Tickenham. He afterwards lived at Bristol; he removed from there to Congesbury, where for some time he had a shop of his own. Wiles for some years has been a man of notoriously bad habits and character. He deserted his wife and numerous family, and has been wandering the country in various directions, working in London, Bath, Bridgwater, and other places frequently earning good wages, but never assisting his family. Seven of his children are living – some married and others out at service. His wife is residing in Portishead with her mother, who has a small income. The prisoner has been frequently in gaol, and was convicted of a felony at last Midsummer Sessions [he received three months in gaol for stealing a pair of trucks]. Another detainer for attempted robbery was lodged against him.

Little was known about John Smith except that he was thirty-two years old, was not a Somerset man and 'was believed to be respectably connected'. Smith gave no clues as to his past other than he had worked as 'an excavator in London, Staffordshire and on several railways; also he did not wish his family to be known as 'persons relating to a man who had suffered death for murder'.

It was reported that Wiles and Smith had only met the Sunday before the murder near Wootten Basset and during the following days had gone from place to place in the area, sleeping rough or in lodging houses and begging at several public houses.

The *Taunton Courier* wrote that once back in the condemned cells, both men made full confessions to the murder, acknowledged to be deserving the fate that awaited them and during their remaining days 'could not have behaved with greater propriety spending much time in prayer'.

On their last Sunday, 20 April, the condemned sermon was preached in the prison chapel and both prisoners were reported to have 'wept bitterly'.

The *Courier* wrote that during the night before their execution, Wiles and Smith appeared to sleep soundly at intervals. They commented further:

There was nothing the previous evening either in front or around the prison, to indicate the awful scene that was to transpire on the morning. The drop was erected before day break, which is the labour of only one hour. The prisoners rose at 5 o'clock this morning, and after being engaged in prayer for a considerable period, partook a little tea and bread and butter. At eight they were taken to the chapel. The prisoners met at the door leading into the chapel, Wiles turned to Smith and extending his hand said, "Smith we have both been guilty of this dreadful crime, let us forgive each other, and pray to the Saviour to forgive us," – Smith took the proferred hand and replied, "Yes, we have, and I hope the Lord will pardon us." The morning service was performed, and the Sacrament again administered. At 9 o'clock the governor announced to the under sheriff that the prisoners were ready, and time for the procession to move. The prisoners walked to the under ward of the hospital, where Calcraft [William Calcraft (1800–1879) the public hangman] performed the necessary portion of his duties. The chaplain, reading the burial service, followed by the prisoners and Calcraft, the governor, and the officers of the gaol, proceeded across the square of the prison to the north-west end of it, on which the drop was fixed.

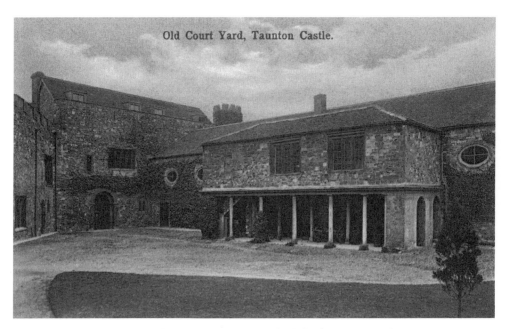

Old Court Yard, Taunton Castle.

Wiles and Smith stood trial at the Somerset Assizes in the hall of Taunton Castle.

At quarter past nine o'clock the prison bell, sounding its slow but melancholy note, announced to the crowd outside that the procession was ascending from the interior of the building. Two warders first mounted the drop of the platform; then Calcraft followed by the prisoner Smith; and then Wiles. The clergyman was behind the prisoners, concluding the burial service. Calcraft quickly placed the men under the fatal beam, and completed fixing the ropes, &c. The clergyman was afterwards engaged in prayer for six or seven minutes before he left them, and they were then in an instant launched into eternity. Life appeared to be extinct in a few moments.

The prisoners walked up the stairs without the slightest assistance, and to the latest moment their firmness never gave way. After the usual period of an hour had elapsed the bodies, were taken down, immediately placed in coffins and buried within the precincts of the gaol. and the drop was in a few minutes removed.

A large number of persons were congregated in front and around the gaol, of both sexes, and of the usual class, but by no means so numerous as on former occasions; and they conducted themselves with great decorum.

All prisoners under sentence for felony and transportation witnessed the execution.

Up and Over

The Bournemouth Easter Flying Meeting on the 5-mile triangular circuit at Ensbury Park was held on Good Friday, 14 April 1927, Saturday, the 15th and Easter Monday, the 18th; flying was not permitted on Easter Day.

Over the three-day event, at least 1,400 people came to watch the 153 aircraft of thirty differing types participate in the twelve events sponsored by various Bournemouth businesses.

Crashes and engine trouble were not uncommon and on Saturday a Sopwith Swallow with a first-time flyer as passenger suffered engine trouble and crash landed – fortunately neither the pilot or his 'rooky' passenger were badly hurt.

There was a crash at the start of the first race on Easter Monday morning when the Hampshire Aeroplane Club's entry suffered engine trouble on take-off and crash landed, thankfully both pilot and passenger climbed out unhurt.

The Bournemouth & District Hotels and Restaurant Handicap Sweepstake was the second event on Easter Monday morning. Representing Bournemouth's Royal Bath Hotel in the first heat was the Yeovil-based Westland Aircraft Co.'s Widgeon III - G-EBPW, flown by Squadron Leader T. H. England with Mrs Alice J. Openshaw, the daughter of the firm's managing director, Mr R. A. Bruce. However, shortly after take-off, disaster struck: the Widgeon developed engine trouble and in the emergency landing the machine turned over. However, to everyone's relief, the pilot and Alice released their seat belts and scrambled out unhurt.

Alice had married Westland test pilot Major Lawrence Openshaw, in Yeovil's St John's Parish Church on 13 April. Following the ceremony, the couple had driven straight to the Westland aerodrome and flown down to Bournemouth in the Widgeon III for the Easter meeting.

Alice's husband Lawrence won the third heat of the second event sweepstake in a Westland Widgeon II but came second in the final losing to star flyer Bert Hinkler, piloting an Avron Avian.

Tragically Alice's marriage was to last less than two months when Lawrence was killed in a crash at the Bournemouth Flying Meeting on Whit Monday, 6 June, flying the Westland Widgeon III - G-EBPW. It was during the first race in the afternoon when the Westland machine collided with the Blackburn Blue Bird flown by Squadron Leader Walter Longton, a well-known Royal Air Force test pilot and stunt flyer. Both aircraft crashed and burst into flames killing both men with their horrified wives looking on.

On a blustery Friday afternoon twenty-nine years later on 17 August 1956, a small two-seater, de Havilland, Tiger Moth bi-plane, G-ANOZ owned by Universal Flying Services of Fairoaks Aerodrome, near Chobham, Surrey, and flown by members of a Surrey Flying Club, started its take-off run on the Westland's Yeovil airfield. Caught by a sudden crosswind, the aircraft tipped, the right lower wing hit the ground and swinging to the right, the Tiger Moth ran down the northern slope of the airfield, through the perimeter fence, across a footpath, a stream and turned over as it hit the hedge lining the edge of the Westland's sports field leaving the pilot and his passenger unhurt suspended in their harness.

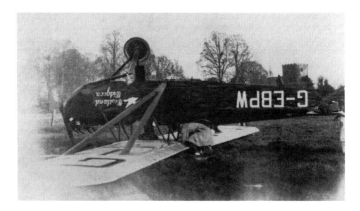

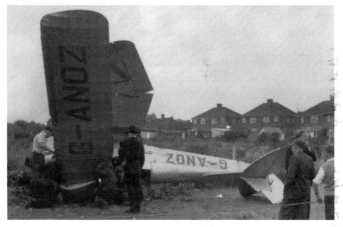

The two inverted aircraft:
The Westland Widgeon III
(*above*) and the de Havilland
Tiger Moth (*below*).

A number of youngsters playing in a garden, Westbourne Grove, which bordered the sports field, witnessed the crash, and one of them, twelve-year-old Robert Holmes from Preston Road, described what he saw to a *Western Gazette* reporter: 'I was watching the 'plane take off and I saw the right wing hit the ground. It appeared to get out of control and ran down the slope of the aerodrome. Then it went through a barbed wire fence and hit some trees.'

Some years later, in 2016, Robert Brookes also recalled witnessing the crash:

The Tiger Moth was taking off in a cross wind when it suddenly veered off the runway and eventually coming to rest upside down in the trees and bushes on the boundary of the Westland's sports field. We children all ran across to the wreck which was inverted in the hedge. The two crew members, a man and a woman, were unhurt but left suspended in their harness. I remember the strong smell of fuel and immediately thought of the fire risk which was only heightened when an off-duty policewoman from a nearby house rushed up and was actively smoking. The silence was almost immediately interrupted by the arrival of the airfield emergency service and I can still see and hear in my mind the fireman who spotted the policewoman smoking. I certainly learnt several new impressive swear words that day!

The Tiger Moth was badly damaged but, thankfully, the two flyers walked away unhurt.

Disgraceful Football

A century ago football could generate passion and disorder, but it appears so occasionally that when it happened the local newspapers became quite indignant about the behaviour of the players and spectators.

Bad language was considered a serious offence, and so was dissention. On 7 March 1892 *Pulman's Weekly News* reported that at the recent meeting of the executive committee of the Dorset County Football Association, Sergeant-Major Butler had stated that Gunner Rundell in the match Weymouth v Royal Artillery had deliberately kicked the football away and refused to fetch it when asked. However, as the Gunner had apologised for his actions, it was decided not to suspend him. Not so in the next case presented by a Mr Guppy regarding the bad conduct and foul language of two players named Stone and Henning of the Wyke Regis Club in a match with Lyme Rovers at Bridport. The executive committee considered the offence very serious and suspended Stone for twelve months and Henning until 1 January 1893.

In the final of the Somerset Senior Cup, played at Wells on 24 April 1905, the *Western Gazette* carried a headline 'Disgraceful Rowdyism at a Football Match' and went on to report:

One of those regrettable incidents which bring manly and healthy sports into disrepute, occurred on the football field at Wells, Somerset, on Easter Monday, whilst a match was in progress between Clevedon and Paulton Rovers in the final of the Somerset Senior Cup. A large crowd had assembled on the field to witness what was considered the match of the season, and they were no way prepared for the unpleasant surprise in store. The game started at 3.15, and Paulton winning the toss played with the wind in their favour. The first half of the game was very fast, but it was soon seen that Clevedon was the better team. With their short passing and combination they kept the ball in the enemy's quarters. The Paulton men at an early stage of the game commenced to indulge in the antics which justly given them an unenviable reputation, and Mr A. W. Stacey, the referee gave foul after foul against them. Moxham scored the first goal for Clevedon with a high shot, which the goalkeeper was unable to save, the ball gliding over the tips of his fingers. Nothing further was scored and at half-time Clevedon were leading by one goal to nil.

When the game restarted Paulton tried hard to equalise, but the Clevedon men were ever on the alert and frustrated all attempts at scoring. Within 15 or 20 minutes after play had been resumed an unfortunate incident happened. Mark Reed, Clevedon's outside left, was taking the ball down the field, when he was tackled by Charles Reakes, one of the Paulton team. He failed to get the ball, and, throwing sport to the winds, struck Reed twice in the face. The referee saw the act, and immediately came up and ordered the player off the ground. The Paulton captain and his men resented the action of the referee and declared they would not continue the match if Reakes left. Mr Stacey, was, however firm. Then followed one of those disgraceful exhibitions of rowdyism which are becoming all too frequent on the football field. The Paulton spectators broke over the wire, crowded on the ground, spreading disorder and confusion around, and making

football impossible, Mr. Stacey, who, by-the-by, is one of the best referees in the county, remained calm and firm, and expressed his readiness to allow the game to proceed if his decision was adhered to. The Paulton team, still continued to uphold the action of their man, and at last the attitude of the crowd became so threatening that the police closed around Mr. Stacey and kept him in their midst till he was got off the field. Play was then at an end, and in the various parts of the field free fights were in progress, which the police were utterly helpless to quell, there being only four constables in a crowd of 5,000. As Mr. Stacey walked down the road in the company of a constable, he was greeted with cries of 'Well done, Stacey', and 'Good old Stacey'. His firm action was highly commended by the great majority of the spectators, who went away greatly disappointed at the result of the game, and thoroughly disgusted with the conduct of Paulton. Action now lies with the County Committee, and the hope is that their action will be of a drastic character. The conduct of Paulton has for some time been derogatory to football in Somerset, and Monday's incident was, unfortunately, simply the culmination of a series of acts of rowdyism on the part of Paulton.

The County Association met in the Hare & Hounds Hotel, Shepton Mallet, on the Tuesday evening of 2 May, where they considered the 'misconduct at the Senior Cup Final tie at Wells on Easter Monday'. Mr C. J. Lewin presided, and told the meeting that the emergency committee had already awarded the cup to Clevedon and the Association's task was to consider the suspension or otherwise of players and officials. Mr Stacey's report on the match was read, in which he stated that 'He was hustled, threatened, struck on the nose, and struck at with a stick, and had it not been for the police and friends, he believed the consequences would have been very serious. The Paulton team refused to renew the game'.

The outcome of the meeting was the suspension of Charles Reakes until 31 December 1905, and the exclusion of Paulton Rovers from the knock-out cup during the 1905/6 season.

On 2 May 1905, the Somerset County Football Association met at Shepton Mallet in the Hare & Hounds Hotel, shown on the right of this photograph, to consider the misconduct at the Senior Cup Final.

Poaching and Other Activities

The stories that follow reflect in some ways the varying attitudes of the occupiers of land in the countryside.

On Friday 27 July 1860, twenty-six-year-old Henry Genge of Hardington Mandeville, appeared before the magistrates on charges of assaulting George Purchase, Police Constable Joseph Bartlett and Francis Dawe. The bench was told that George Purchase was one of Lord Portman's gamekeepers and that in September 1859 he had taken out a summons against Henry Genge for poaching on Portman land. Genge had immediately left the district, but was back in Hardington on 23 July and seen by George Purchase. The gamekeeper stated that when he called out to Genge the prisoner had attacked him: punching him to the ground, kicking him, seizing his shotgun and beating him around the head with the butt-end. Constable Joseph Bartlett had been called out and, in company with farmer Francis Dawe, had gone looking for Henry Genge. However, Genge was not someone who seemed to take kindly to gamekeepers, policemen and farmers, because when they found him and tried to take him into custody, both the

Some years before this family group were photographed in Nine Springs several lads were cautioned for trespassing on nearby land.

officer of the law and his farmer assistant had a battle on their hands. Finally restrained, Henry Genge was taken to Yeovil police station and brought in handcuffs before the magistrates, who committed him to stand trial at the forthcoming Somerset Assizes. Four weeks later, Henry Genge appeared before a judge and jury at the assizes, where he was found guilty on all three charges and sent down for six months' hard labour.

Labourers William Knowles and John Webb stood before the magistrates at Ilminster on 28 December 1894, charged with trespassing in pursuit of game in the daytime at Drayton, near Langport, on 3 December. Police Constable Higgins testified that at around 11.45 a.m. he was on duty in Drayton Lane and saw the two defendants in an adjoining field, called Twelve Acres and owned by Mr E. C. Trevelian. He had observed the defendant, Webb, carrying a gun, and a dog was 'working the hedge'. In reply to a question from the chairman of the bench, the constable confirmed that Webb possessed a gun licence and that he was around 250 yards away from the two men when he first saw them. In his defence, William Knowles denied being in the field: 'We weren't near the field by a mile,' he said.

A second charge for a similar offence was brought against William Knowles when Charles Best, Mr Trevelian's gamekeeper, testified that he had seen Knowles and another man, whom he could not identify, in a plantation at Drayton on 15 November. He stated that he saw them put down nets and a ferret in a rabbit hole but, after seeing the gamekeeper, the pair ran off, leaving the ferret, which he had caught; Charles Best admitted that it was getting dark when he saw the men. In this defence, William Knowles declared that on the 15 November he had been working for the haulier George Crossman, hauling coal all day from Langport railway station and had gone nowhere near the plantation. Called as a witness, George Crossman confirmed that Knowles had been with him from 8 a.m. until 6 p.m. on the day in question. However, in reply to a question from the bench as to which day of the week it was, the haulier replied that he didn't know. The clerk observed to the magistrates that the November floods had been at their highest on 14 November and Langport station had been under water for some time. Commenting that George Crossman might have been mistaken as to the day, the magistrates gave William Knowles the benefit of the doubt and dismissed the case but found him guilty, together with his co-defendant John Webb, on the first charge and each were fined 5s.

In December 1865, seven Yeovil lads were brought before the local magistrates, summoned by PC Clarke for trespassing near Ninesprings on Mr John Batten's Aldon estate. Following the advice of the chairman of the bench, all seven pleaded guilty to the charge and admitted that they had gone in search of chestnuts. Mr Batten subsequently declined to press the charge 'on the boys begging pardon for the offence', and they were dismissed with a caution.

Finally, in August 1901, rabbiting with permission took place on Mr Bown's wheat field at Higher Mudford. The wheat was being cut by machines until only a small square remained in the middle of the field and in which a large number of rabbits had taken refuge. However, as they made a bolt for freedom, the harvesters and their friends were waiting; those that escaped being knocked over and killed with heavy sticks were taken by dogs. After an hour, over 100 rabbits had been despatched and the remaining wheat was cut.

Robbery at Wedmore

Farmer William Redman had retired from the office of Wedmore Overseer on 31 March 1845, and on Saturday 29 April of that year he had spent the evening at the home of the vestry clerk, closing the books and transacting various items of business. He left for his home at Blackford on foot at around 11 p.m. and, as he approached Heath House Windmill, made out two figures standing back from the side of the road on his right. The road was a lonely one, so the farmer held out a sharp pruning knife – something he always did when walking alone after dark – and was prepared to use it if necessary. For a moment he felt uneasy, as he was carrying the large sum of £15 in two £5 banknotes and the rest in coin. However, the night was clear and, in the faint light of a half-moon, as farmer Redman came closer, he recognised one of the figures as young George Hooper, who had once lived and worked on his farm, and the other was one of James Williams' boys from Wedmore. The sense of unease departed and, as he passed, the farmer called out 'Halloa, my lads!' Even so, he wondered what they were about at this time of night. Moments later, he found out.

Both young men suddenly rushed at him: Williams delivered several violent blows to the Redman's head and Hooper hit him with a bludgeon. Despite the blows, William Redman remained on his feet and laid about him with the sharp pruning knife. He felt the blade strike home again and again, followed by grunts of pain, but the blows kept coming and the fighting farmer was finally battered to the ground, shouting 'Murder! Murder!' Williams leapt on him, a rag was stuffed into his mouth to stem his cries, his neck was grabbed, and attempts were made to break it by violent twists. Hands were in Redman's pockets and he felt the purse containing the banknotes and coins savagely torn out. Suddenly his assailants departed, leaving William Redman covered in bruises with a tooth missing and several broken, and two black eyes. Staggering to his feet, he managed to get to the door of the mill and raise the miller.

Somewhat recovered from his beating the following morning, William Redman and Wedmore parish officials returned the scene of the crime and found blood stains on the road, which, on being followed, led them through the village to the home of James Williams at Quab Lane. Here they discovered that neither James nor his nineteen-year-old son Edward were at home, and further enquires revealed that Edward had returned the previous night bleeding heavily from cuts to his face and arms. The wounds had been roughly bandaged at around 3 a.m., after which James had placed his son in the family cart, covered him with a sheet and, in company with George Hooper, had left for Backwell.

Later that morning, the pursuers ran down their quarry to the George Inn at Backwell, where they found James Williams, his wounded son, and Hooper claiming that the serious cuts had been due to fighting off a man who had tried to steal the cart the previous evening. Earlier, a surgeon had tended the cuts, and James Williams had paid him with a £5 note. The surgeon was visited and the banknote identified as one stolen from farmer Redman, along with a second that had been changed by Williams Snr.

The three were taken into custody and appeared at the Somerset Assizes in Bridgwater on 5 August 1845. Edward Williams (still bearing the scars on his face)

Farmer Redman was attacked and robbed returning home from Wedmore on 31 March 1845.

and George Hooper, both nineteen years old, were charged 'with assaulting William Redman on the highway, and robbing him of two £5 notes and other property', and James Williams for 'receiving two £5 promissory notes knowing the same to be stolen, the property of William Redman'. The two young men were found guilty and sentenced to be transported for life, and James Williams was found guilty and sentenced to six months in prison.

On 7 January 1846, Edward Williams and George Hooper, together with 198 male convicts, were taken on-board the prison ship *China*, which left Woolwich on the same day and docked at the notorious prison colony on the remote South Pacific Norfolk Island four months later on 16 May. Accompanying the two were the following Somerset convicts, sentenced to serve their time in this brutal penal colony: James Adey, Mordecai Bolwell, George Bridges, Edward Bryant, Francis Burt, Robert Chard, John Cook, Henry Coward, Aaron Dominy, James Flower, William Hake, Henry Hale, Jonah Sage, and John Williams.

In Brief

Bath

The *Western Morning News* mentions an amusing incident which took place near Bath a few days ago. The River Avon where it passes through the property of one of the leading landowners is strictly preserved. The other day a keeper on the estate came upon a gentleman who was fishing in the forbidden waters. 'Pack up your traps and be gone,' said the keeper. 'Do you know who I am?' said the gentleman. 'Yes, you are the Mayor of Bath,' replied the first, adding with the utmost seriousness, 'and if you don't make off this minute I will bring you before yourself tomorrow.' It need not be added that his worship the chief magistrate beat a retreat rather than face his own magisterial wrath.

The Western Flying Post, 20 November 1866

Burnham

On Wednesday evening a number of young fellows evidently bent on practical joking, and hailing from a neighbouring town are alleged to have 'stolen' the Clarence Hotel bus and horse. They removed it from the station-yard and drove it hurriedly towards Burrow, and around Brent Knoll. Eventually the horse and bus were turned adrift near Highbridge. The affair is in the hands of the police.

The Western Gazette, 7 July 1895

Cannington

On Wednesday morning last, Richard Dell, son of Mrs. Dell of Cannington, got up from his bed whilst asleep, put on his trousers, boots and hat, wrapped a blanket around his shoulders and walked off to Kingston, near Taunton. He arrived near the Swan Inn, Kingston, soon after four o'clock in the morning. When he was awakened he walked home again, by way of Asholt after partaking of refreshments.

The Western Gazette, 14 October 1870

East Chinnock

Miss Kate Rendell, who mysteriously disappeared from home on Thursday week, returned home on Wednesday evening, to the intense relief of her relatives. She was in too weak a condition to give any explanation of her absence. History is silent on where she had been.

Pulman's Weekly News, 17 October 1899

The 'stolen' Clarence Hotel horse bus was driven around Brent Knoll in July 1895.

Langport

On Saturday week, a young man, Henry Purchase, of Drayton, committed the act of foolishly riding his horse along the railway not thinking it any harm for upwards of a mile. On reaching the station he was taken into custody and immediately introduced to the magistrates, who fined him 10s and 5s costs.

The Western Flying Post, 11 July 1854

Oakhill

A performing bear was lodged in Mr. Parson's stable at Oakhill recently, and whilst one of its keepers (a Frenchman) was in the act of feeding it, the brute seized him by the leg. The man's companion caught hold of the bear, and, after a sharp tussle, succeeded in getting the man's leg out of its grip. He was taken to Shepton Mallet Hospital where the injured limb was attended to.

The Western Gazette, 23 June 1871

Taunton

Two of those beautiful little birds, called Kingfishers, were killed on Tuesday last in the neighbourhood of Taunton, at one shot, by Mr. Birch of Creech. These birds are rarely seen on the banks of the Tone.

The Western Flying Post, 6 October 1828

A person residing in this town having lost some fruit from his garden has made a compound of chemicals with which he occasionally inoculates some of his choice fruit. Early on Tuesday morning a fellow having scaled the wall and freely partaking of the good things before him, was found in the road in a state of great suffering from the effects of what he had just eaten, and it was only by recourse to an emetic, that he was relieved of his suffering.

The Western Flying Post, 11 July 1854

Westbury-sub-Mendip

At the County Police-court [in Wells] on Monday 2 January, John Stott (15), George Card (14), and John Lumber (14) of Westbury, were charged with stealing a basin containing a Christmas plum pudding and a cloth, value, 4s, the property of Edgar Sealey of Westbury. It appeared that on the evening of 23rd December, Mr. and Mrs. Sealey were absent from home and that the boys went to the house and asked for some cider, which was given them. They then left but returned as soon as the door was closed, and, going into the back-house took the pudding out of the boiler where it was cooking. - After hearing the evidence of Mrs. Francis Sealey, Joseph Carver, and P.C. Woonton, the Bench fined defendants 5s each, including coats.

Western Gazette, 6 January 1888

Yeovil

At the County Sessions on 19th June, Norman Ring (20), a Canadian employed as a aircraft fitter, living at The Rectory, Barwick, pleaded guilty to photographing a military tank, contrary to the Defence Regulations. P.C. Stevens stated that the defendant admitted photographing the tank and that he was aware of the regulations and knew he should not have done so. The film was recovered.

Defendant asked to account for his actions said that photography was a strong hobby with him. 'It is more or less a passion with me,' he added.

The Chairman imposing a fine of £15 and ordering the camera to be confiscated commented, 'You can consider yourself extremely fortunate not to go to prison, it was touch and go whether you did so or not. You knew you were doing wrong but you persisted in it.'

Western Gazette, 21 June 1940

Lost in the Snow

Just inside the main gate to the churchyard of the fifteenth-century parish church of St Mary Magdalene in Exford stands a headstone in memory of twenty-four-year-old farmer Amos Cann, who died in March 1891. There is no exact date of his death because it would seem no one could be sure.

February 1891 was a very fine and dry month. The nice weather extended into the first week of March, after which it changed dramatically. On Monday 9 March the barometer and temperature fell rapidly, and at midday a blizzard roared in on a north-east gale. Heavy snow swept across the North and Midland counties but the South West bore the brunt of the storm.

As temperatures continued to fall, the storm increased in intensity during Monday night; there was a brief lull on Tuesday morning but by the afternoon the blizzard returned and raged on until Wednesday, when the skies cleared as the storm had passed over. In its wake it left roads and railways blocked by huge drifts bringing travel to a standstill, and towns, villages and isolated communities were cut-off in the blanket of heavy snow. At sea, ships ran for shelter, but some never made it and were driven on shore or rocks with loss of life. Even the royal family were affected when, on the Tuesday evening, the train carrying Prince Alfred, the Duke of Edinburgh, from London to Plymouth could travel no further than Taunton due to the deep drifts blocking the line. Prince Alfred was put up in the Railway Hotel until normal services were resumed on Thursday morning, when he proceeded on his way.

Amos Cann lies in Exford Churchyard just inside the main gate.

Dartmoor and Exmoor were badly hit by the blizzard and the deep snowdrifts would take weeks to melt. The local newspapers were full of reports on the storm and especially the narrow escapes by people caught out by its ferocity. Tragically, one young Exmoor farmer was not so fortunate and became one of the victims of the blizzard of 1891.

Amos Cann was the son of farmer Richard Cann, and early in the afternoon of Monday 9 March, took two horses down to their purchaser in Porlock. It was snowing when he arrived but, no doubt being an Exmoor man, snow was something with which he was familiar, and in any event he was well dressed with a heavy, warm overcoat. Amos therefore decided not to stay on in Porlock and at around 7.30 p.m. set out to walk the 7 miles back home to Greenland Farm, near Exford.

To begin with his parents were not too concerned when he did not arrive back that evening – a blizzard was howling outside and doubtless Amos had stayed on in Porlock. However, when he had not arrived home on Wednesday and the Canns were told that he had left on Monday evening, they knew something was very wrong, so parties of local men began a search back along the road to Porlock. For three days an intensive search of the deep drifts along the road was carried out, but without success. Mr Bassett, the master of the Devon and Somerset Staghounds, lent his pack for the search but still there was no sign of the missing young farmer.

Although by now there was no hope of finding Amos alive, the search of the melting snow and drifts continued; seventeen days later, during the morning of Thursday 26 March, Amos's overcoat was found around a mile from his home and his body was discovered a few hours later about a quarter of a mile away. The young farmer's head and feet were just visible above the melting snow of a deep drift, and when it was cleared away his arms and legs were found to be crossed.

How Amos met his sad end was the source of some speculation in the local newspapers. On April 1 the *Taunton Courier* suggested that:

> It was supposed that he threw this [overcoat] away in order to make his progress through the storm easy. From the position of the body it is supposed that the deceased was crossing the road in order to get over a hunting gate and to cross some fields and that he turned his back in the storm to recover is breath, sank down and went to sleep. He did not appear to have struggled at all and his body was as fresh as though death had only just taken place.

Amos Cann was laid to rest in St Mary Magdalene's Churchyard. It was not known whether he died on 9 or 10 March, which would appear to be the reason why the date was not inscribed.

Dangerous Skies

On Friday 23 May 1913, when flying was still in its pioneering days and still a mystery to many, the *Western Gazette* reported on the lucky escape of two army flyers in a crash near Sparkford:

On Saturday morning an Army aeroplane came to grief at Little Weston, near Sparkford, and its occupants Lieutenant Burroughs, of the Royal Flying Corps, who was the pilot, and a sergeant of the same Corps, with him as passenger, had wonderful escapes from death. The aeroplane, a Henry Farman biplane, with a 50 hp Gnome engine, left Larkhill, Salisbury Plain, early on Saturday morning, and made a most successful flight for many miles in a south-westerly direction. The machine was seen going in this direction over Maiden Newton, and later reached the neighbourhood of Bridport, over which town they were seen. The pilot turned north on sighting the sea, and the aircraft was observed over Yeovil about half-past eight, flying very fast and high in an easterly direction, and a few minutes later was seen over Adber, Marston Magna, and Sutton Montis. The aviators, when approaching Little Weston, were uncertain as to their whereabouts, and the pilot, when about 2,000 feet up, switched off his engine and planed down for the purpose of making observations. The machine came down to the required height, but when the aviator desired to go up again the engine refused to start, and the only choice left to the pilot was to make a landing. This seemingly presented no great difficulty, for under them they saw what looked to be a beautifully smooth field, and in this they decided to alight. Unfortunately the smoothness of the field was more apparent than real, for a thick crop of mowing grass concealed many inequalities of the ground, mostly ridges and deep furrows left by the plough when the meadow was formerly cultivated as corn land. The aeroplane's landing gear striking these ridges obliquely was unable to keep the machine on an even keel, and it turned a somersault with disastrous results before going many yards. The pilot and passenger were thrown many yards away in different directions, fortunately quite clear of the wreck, and escaped with very severe shakings and some cuts and bruises. The aeroplane, apparently new or nearly so, was smashed out of recognition. Little remained of the propeller, though the engine seemed little the worse, but the seats of the aviators was a crumpled mass of aluminium and wires, and the remainder of the machine a tangled heap of broken wire, splintered wood and torn fabric. Fortunately, some men were working in fields close by, and promptly rendered assistance, and the aviators were accommodated in a nearby farmhouse. Assistance was wired for to Larkhill, and later a motor car, with officers, mechanics and tools arrived, followed by a motor lorry, on which the remains of the damaged machine were packed and taken back to its quarters.

On the morning of Tuesday 22 November 1945, a converted Liberator bomber of the RAF Transport Command crashed in fog on the Blackdown Hills near Buckland St Mary. The crew of five (four of whom were Polish airmen) and twenty-two passengers, all British Army personnel returning to India after leave, were killed – twenty-six outright, with the other dying on his way to hospital.

At 10 a.m. the transport had taken off from the Royal Air Force station at Merryfield, near Ilminster, some 4 or 5 miles away, but did not gain sufficient height to clear the 900-feet crest of the Blackdown Hills. It had got struck on a tree, caught fire and burned out in a field not far from Castle Neroche, belonging to Mr J. Gent of Castle Farm, Buckland St Mary. The *Western Gazette's* reporter, who visited the scene, wrote:

> It is an appalling spectacle, with wreckage strewn about the grass field. Part of the plane had gone over the hedge into Hare Lane, which runs alongside the field. One propeller was two fields back from the lane, while other wreckage was in a field on the opposite side of the lane. Articles of Service men's clothing, respirators, foodstuffs and personal clothing were scattered about. The lane itself was blocked to traffic. It is a lonely spot and no other property was endangered. I gather that two men for whom accommodation had been reserved on the plane arrived at Merryfield too late for the journey. Mr. E.W Manley of Lindmoor Farm, Buckland St. Mary who lives half a mile from where the aircraft crashed, said that the conditions on Thursday morning were so foggy that it was impossible to see more than 100 yards ahead.

It appears that that there were no eye witnesses to the tragic crash. And who were the two men who missed the flight? Signaller Ken Barber from Yeovil and Lance-Corporal Frank Bowen, both recently married. On the day before the departure both had been

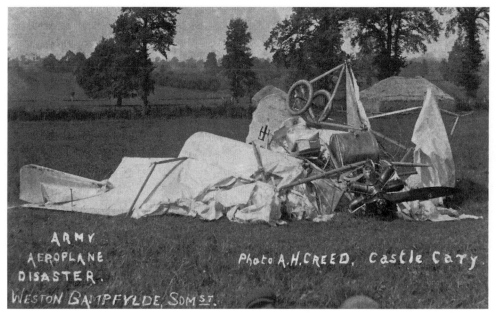

The wreckage of the aircraft from which Lieutenant Burroughs and his passenger escaped with cuts, bruises and a severe shaking.

at Ilton, a few miles from Merrifield, and given twenty-four hours embarkation leave. However, Frank Bowen lived too far away to get home and he accompanied Ken to Yeovil. Setting out for Merryfield on the Tuesday morning, their journey back to the airfield was delayed on account of the very foggy conditions on the way, but by the time they reached the airfield the Liberator had left. A short while later they learnt that the aircraft had crashed with the loss of all on board.

Five of the victims were buried with full military honours in the Commonwealth War Graves Commission's plot at Yeovil Cemetery, where they still lie in peace. They were Major Harry William Staunton (Indian Army Medical Corps), Lieutenant Peter Biles (Indian Army Medical Corps), and three signalmen of the Royal Corps of Signals – Roland Oswin Anderson, Owen Williams and Robert Charles Anderson.

The Brighter Cary Club

And now a surprisingly tongue-in-cheek article from *The Somerset Year Book:
1926*. There is a little mystery and humour behind the following extracts, which
appeared in two consecutive issues in June of the *Western Gazette*. Apart from this,
they explain themselves.

Extract One

'A BRIGHTER CARY CLUB'
A CAMPAIGN OF SMILES,
(contributed.)

The first monthly meeting of the 'Brighter Cary Club' was held on Friday to discuss
several important matters, the attendance at the George Hotel being extremely
good in view of the weather conditions.

The President, the 'Marquis of Barrow', in opening the meeting said he felt it a
great honour to preside over such a select assembly. Their Club had been formed
with the praiseworthy object of enlivening the district of Castle Cary and he was

The Brighter Cary Club held their 'meeting' in the George Hotel, shown on the left of the photograph.

sure they were all anxious to do anything in their power to further that object. There was undoubtedly abundant scope for the activities of the Club, and he hoped they would justify their title to the full. As a beginning they had organised a most successful dance at the George Hotel, which had resulted in a substantial sum being credited to the Club funds. In concluding, the President said that he had one request to make, which was that all members of the Club should refrain from alcoholic refreshment and also from working in pairs.

The first item to be debated was 'Should Cats have Tails?' In discussing this question members pointed out that people might stroke an angry cat by mistake if it had no tail to indicate its feelings, and it was also a useful appendage as a handle to eject it before retiring for the night.

'Should Courting Couples be Permitted?' The Committee decided that this was a question over which they had no jurisdiction, but questions on the matter should be asked in Parliament.

'Should Pins have Points?' This provoked a somewhat heated discussion. The lady members maintained that pins were useless as weapons of attack unless they had points. The male members asserted that points conduced to profanity and the general lowering of the moral standard. The ladies replied that pointed pins contributed largely to material uplift in the lower portions of society.

'Kissing is a Desirable Practice.' Contrary to expectation, this subject provoked little opposition. The Secretary, however, vehemently denounced it as a weak habit, generally accelerating the promotion of disease and savouring of cheap sentiment. He was loudly hissed.

The effect of the 'Brighter Cary Club' campaign was then discussed. Members reported that they had noticed broad smiles on the faces of townspeople, which could be traced to the date of the foundation of the Club. A record amount of spring cleaning had been carried, and even the oldest inhabitants began to look young again.

In conclusion the Chairman thanked those present for their attendance, and proposed a hearty vote of thanks to the 'Marquis of Barrow' for facing a long journey in order to be with them that night. He was sure they were all grateful to him for coming. The applause was so great that the lights were extinguished, and in the interval before they were re-lit strange gurgling sounds were heard among the gathering. The meeting then dispersed in a semi-orderly manner.

Extract Two

'THE BRIGHTER CARY CLUB'

It has been brought to our notice on behalf of 'The Brighter Cary Club' that no meeting of the description given in last week's Western Gazette has been held, and therefore this report was imaginary.

The contribution was forwarded to us and printed in good faith. We would suggest that the author should make his peace with the Committee of the Club, who inform us that the effects of his contribution may be that an erroneous view of the activities of the Club will be given. Mr W. Payne of the George Hotel, also protests that there has been no meeting in connection with the Brighter Cary Club as published in our issue of June 11th.

We can only add that we hope the publicity thus given to the affair will have the effect of genuinely assisting in the attainment of the Promoters' objects.

The following, which we have received from a far-off correspondent, has no reference to the foregoing, but seems to have been written by one who is familiar with another of the town's hostelries:-

Britannia needs no bulwarks,
No steadiments beside her,
Her strength is drawn from Cary wood,
Containing Cadbury cider.

I'll Be Even With Thee!

High on the west wall inside the Church of St Michael, which gives the East Mendip village of Stoke St Michael its name, there is a memorial tablet bearing the following epitaph to William Cornish:

<div align="center">

Sacred
To the memory of
WILLIAM CORNISH
Who was Barbarously Murdered
On the 29th of August 1817
In the 51st Year of his Age
Leaving a disconsolate Widow and
Seven Children to deplore their loss
And his untimely end.

</div>

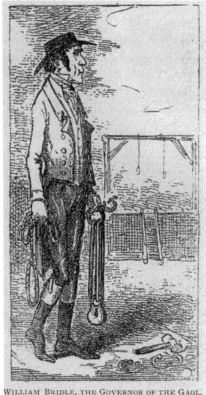

WILLIAM BRIDLE, THE GOVERNOR OF THE GAOL.
(From Hunt's Investigations.)

William Bridle was the Governor of Ilchester Gaol when Mark Sheppard was hanged on 13 April 1818 for the murder of William Cornish.

Mark Sheppard did not like the village shoemaker, William Cornish, and the feeling was mutual. In fact the shoemaker's dislike of Mark Sheppard was such that he had refused to allow him to marry his daughter Mary. As a result, the rejected suitor had been heard making threats against William Cornish.

During the evening of 29 August 1817, Mark Sheppard and a friend by the name of Hancock were drinking in the Waggon & Horses public house (on the road from Shepton Mallet to Frome), when in came William Cornish and Thomas Green. The two men were returning after a long day at Shepton Mallet market and were looking forward to a drink before walking the last few miles home to Stoke St Michael. The four men were reasonably amicable to begin with, but when Hancock, with a tongue loosened by the beer, joked about Mark Sheppard wanting to marry Mary Cornish, the resentments erupted. The two men traded insults and squared up for a fight, but before blows could be struck the landlord Benjamin Cornish stepped in and parted them. With peace restored, William Cornish bought Sheppard some beer, saying that he meant him no ill and the rest of the evening passed off without incident.

At around 10 p.m. the shoemaker, Thomas Green, and Mark Sheppard bid the landlord goodnight and made for home along the road towards Stoke St Michael. Just before they reached the crossroads in the hamlet of Three Ashes, the row erupted again, and Cornish and Sheppard went for each other. Before blows could be traded, Thomas Green managed to keep them apart, and they continued on their way. However, when the trio reached the crossroads there was a further bout of insults and swearing from Sheppard. Not wishing to become involved again, William Cornish turned his back on Sheppard and, with Thomas Green, continued on the way home. Sheppard shouted after them for a few moments, then took the right-hand lane, which also led to the village.

When, by 1 a.m., William Cornish had not arrived home, his wife Hester became a little worried and their daughter Mary was sent to Thomas Green's to find out where he was. Mary had not gone far along the road when, in the light of her lantern, she saw her father lying in the road, horrified to see his that his head was a bloody, shattered mess. Her father was dead. His eyes hung from gory sockets and there was the glint of teeth scattered on the dusty road. Thomas Green and neighbours were called out, and the corpse of William Cornish was carried home.

There was only one suspect: Mark Sheppard. Following a procession of witnesses at the inquest testifying to the threats against the deceased, the jury unanimously returned a verdict of the wilful murder of William Cornish by Mark Sheppard and he was sent for trial at the Somerset Spring Assizes.

Indicted for the wilful murder of William Cornish, Mark Sheppard appeared before Mr Justice Abbott at the assize court in Taunton on 30 March 1818. Witness followed witness to testify about the threats made against the murdered shoemaker. Richard Brown, drinking at the Waggon & Horses on the evening in question, overheard the prisoner cursing and swearing: 'It would be a life for a life before I sleep and it should be damned if it should not'. Landlord Cornish testified that he had heard Sheppard muttering that he would commit a violence of William Cornish before he got home, and that he would die rather than live. Mr Stratford, a resident at Three Ashes, stated under oath to the quarrelling outside his house and that he heard the prisoner shout: 'Cornish I'll be even with you before morning!' The following morning, the witness noticed that a wooden rail had been torn from his garden gate and confirmed it was the piece of wood discovered covered in blood and brains, pushed into a hedge near the spot where the body of William Cornish was found. Rossiter, the parish constable,

produced the coat and cravat Sheppard had been wearing on the day of the murder and showed the jury the spots of blood on the garments.

Mark Sheppard had not confessed to the crime and there were no witnesses to the murder of William Cornish, but the circumstantial evidence and the testimony of the prosecution witnesses appeared overwhelming and was sufficient to convince the jury of his guilt. After a brief discussion, the jury found Mark Sheppard guilty of the wilful murder of William Cornish who, according to the *Western Flying Post*, had behaved with shocking levity during the trial and appeared quite unconcerned when Mr Justice Abbott passed the dreadful sentence of death.

Mark Sheppard was executed by hanging at Ilchester Goal on Monday 13 April 1818 and his body sent to Bridgwater for dissection at the Medical Institute. The prison chaplain wrote in his daybook that the condemned prisoner had refused to take the sacrament, but within a few minutes of his death confessed that he had murdered William Cornish.

A Gang of Burglars

In the autumn of 1843 a gang of burglars was at large in the Wincanton area. Among the outrages, the outhouse of Grocer Bracher was broken into and a large quantity of cheese stolen. The counting house and shop of leather manufacturer Mr George was also ransacked and a substantial amount of leather and other goods carried off; the haul included, strangely enough, a counterfeit shilling and two counterfeit sixpenny pieces. Mr George immediately issued handbills in Wincanton detailing the stolen property and offering a £5 reward for the arrest of the offenders. Within hours there was a result: a woman, who lived with a local man called Uriah Gawler, bought some goods in Mr Shaw's grocer's shop with two counterfeit sixpenny pieces.

Gawler was quickly arrested by Robert Green and Charles Dyke, the Wincanton constables, and confessed to breaking into Mr George's premises in company with a man by name of Clewett. During the search of Gawler's house a number of stolen articles were discovered, including some locks belonging to a Mr Feltham and tools taken from a young apprentice called Sandford, who was employed by Mr Meaden, a Wincanton coach maker.

Acting on the confession, the two town constables searched the beershop of one Couzens, long suspected as being a receiver of stolen goods. A quantity of leather was found, together with some straps that Mr George stated he had made some time ago for Mr Ward, a silk thrower of Bruton. Couzens was arrested and taken into custody.

The five Wincanton burglars were transported to Australia in 1844.

Following the arrest of Couzens, John Salmon, Mr Ward's foreman, was questioned and confessed to stealing the leather straps and other articles from his employer and selling them to a man called Sansom, a Wincanton rag dealer. In turn, Sansom was arrested and admitted selling the goods received from Salmon to Couzens. And so the gang was rounded up and committed for trial at the next Somerset Quarter Sessions.

It seems that once Gawler began his confession, he could not stop talking. He described how he had broken into Bracher's grocer shop and stolen the cheese, some of which he had shared with Clewett, but the greater quantity had been sold to Couzens. He admitted also that several other robberies had been planned for the coming winter, including a raid on Charlton Musgrove Church.

On Thursday 21 November 1843, with the culprits in custody, a meeting of householders was held in the Wincanton Town Hall, where it was agreed to form a society for the protection of property and the detection of offenders. Ironically, Dr Eastment, one of the convenors of the meeting, was burgled during the evening he was attending the meeting, and a quantity of cider was stolen.

In January 1844, the gang, all described as old offenders, were found guilty of theft or receiving stolen goods and sentenced to transportation to the Australian penal colonies for various terms – Gawler, twenty-one years; Clewett and Salmon, ten years; and Sansom and Couzens, seven years.

Fatal Tracks

It goes without saying that railways can be dangerous places when they are operational, and also being constructed, as the tragic deaths of two teenagers in Yeovil, nearly sixty years apart, can testify. On Tuesday 26 December 1846 the *Western Flying Post* reported:

On Saturday last an Inquest was held at the John Bull Inn in this town, on the body of Charles Baker, aged 13 years when, from the evidence adduced, it appeared that the deceased was employed by the Wilts, Somerset and Weymouth Railway, near Yeovil; that in the afternoon of the Wednesday previous, the deceased was with others at work in a cutting when a large quantity of earth suddenly gave way and fell on him and caused his death - it was also proved to the satisfaction of the jury, that every possible care had been taken to guard against such dangers, and so to prevent accidents, that the state of the work had been examined, and so no blame could attach to anyone. In consequence the jury returned a verdict 'that the said Charles Baker came by his death by a large quantity of earth falling on him, whilst at work on the Wilts, Somerset and Weymouth Railway.' We understand that four men were working with the deceased at the time the accident occurred, but they fortunately escaped without the least injury.

Young Robert Pearse was killed crossing the tracks near the Pen Mill engine shed.

Fourteen-year-old Robert Pearse was working as a railway engine cleaner at Pen Mill station on 24 April 1901, but as he crossed the tracks he was knocked down and killed.

The account of the tragedy appeared a few days later in the *Western Gazette* on 26 April 1901, when the newspaper told how the young lad had been knocked down and killed by a shunting engine as he crossed the railway lines at Pen Mill station. The inquest was opened on 25 April in the Pen Mill Hotel by the coroner, Mr E. Q. Louch, and after viewing the severely mutilated body, the members of the jury visited the scene of the accident under the bridge that carried the Sherborne Road over the railway.

Back in the hotel, the first witness was Alfred Paynter, foreman of the Pen Mill locomotive shed, who stated that Robert Pearse had come on duty at 6 a.m. and at around 11.15 a.m. he had been sent on an errand to the station. The foreman stated that the lad had been working in the shed for around five months and was quite used to walking along the railway lines and knew the crossings.

Albion Helps, a goods porter, told the inquest that on the morning in question he had been walking by the line towards the station platform when he saw Robert Pearse cross the tracks under the bridge, and at the same time he had glimpsed an engine with two coal trucks reversing towards the lad. He had shouted a warning but it was too late – the youngster was knocked down by the train. Albion Helps went on to describe how the wheels of the trucks and engine tender had passed over the boy cutting him in two. The witness thought that the noise from a passenger train standing in the station had prevented Robert from hearing the approach of the shunting engine.

The driver of the engine, Philip Jones from Trowbridge, stated that he was shunting two coal trucks and had received the signal to proceed under the bridge and into the station. He was familiar with the crossings at Pen Mill and estimated his engine was travelling at around 4 mph when the accident occurred. Driver Jones testified that he had heard no warning shouts and had not seen the deceased on the line as he reversed into the station.

Inspector Daniels of the Great Western Railway told the inquest that there was no pathway between the locomotive shed and the station platform, and employees therefore had to cross the lines. However, there had been no accidents at this place for over twenty years.

A verdict of 'accidental death' was returned with the added rider that no-one was to blame. The jurymen gave their fees, to which the coroner added 2s to Robert Pearse's widowed mother, who lived with her second (and only surviving) son at No. 27 Camborne Street.

Robert was buried in Yeovil Cemetery on the following Sunday afternoon, where a large number of townspeople paid their last respects. The *Western Gazette* reported:

The representatives of the GWR included:- Messrs Parry (station master) and Paynter (Locomotive Department), Foremen Dowding and Galliott, Guards Biggs, Ford and Chick, Brakesman Vardy, Signalmen Davey and Phillips, Drivers Ostler, Sperring and Constable, and Messrs Holly, Woodley and Hitchcock. The remains were conveyed on a Washington Car and two carriages, containing the mourners followed. Six of the deccased's fellow enginemen acted as bearers, viz., Messrs Bollen, Forsey, Seager, Phillips, Udey and Hewlett.

Pleased to Remember the Fifth of November

On 14 November 1866 a local newspaper wrote:

> The 5th of November is celebrated on a large scale at Bridgwater. The inhabitants turn out EN MASS to take part in the demonstration, and from dusk till past midnight the town is kept in one blaze of light with bonfires, discharges of fireworks and other illuminations. Tar barrels were ignited shortly before seven o'clock on Monday evening, and by seven the whole of the spacious area known as 'The Cornhill' the centre of the town was in a blaze of light from a huge bonfire which was fired there. The 'Guys' were just making their appearance, and bonfires in other prominent parts of the town were being lit, when an immense body of flames casting their reflection over the town arose from the neighbourhood of Eastover.

This 'immense body of flames' was no Guy Fawkes bonfire, but a fierce fire that had broken out in the chemical warehouse at the back of Mr Tomkins' shop in Eastover, near the bridge over the River Parrett. The fire had started in a bedroom above the warehouse; by the time it was discovered it had burnt through the wooden floor of the room and into the warehouse beneath. Mr Tomkins' family of five children, two of whom were sleeping in the part of the living accommodation near the blaze, managed to escape before the flames took hold of this part of the building. The fire spread rapidly and threatened an adjacent shed containing a number of barrels of oil. By now a large crowd of spectators had arrived. While a number of men broke into the shed and dragged the barrels out, others formed a chain to fill buckets from the river and pass them to the front, where men threw the water onto the blaze.

Bridgwater's only fire engine had been summoned but, pending its arrival, the bucket chain was the only means of trying to contain the fire, which had now taken hold of Mr Smith's nextdoor tea and grocery establishment. The fire had also spread into the large club room of Lockyer's Temperance Hotel and was threatening Messrs J. Wadden & Sons' rope warehouse containing a large quantity of tow and other inflammable material.

Despite heroic efforts of the bucket chain, the blaze totally destroyed Mr Tomkins' residence and his warehouse, and Mr Smith's tea and grocery establishment. The Temperance Hotel club room was gutted by the flames, and were it not for the arrival of the firemen with their engine, the conflagration could have spread to more neighbouring premises. It took an hour to contain the fire and another to put it out, but in the meantime many willing hands had helped save much of the Mr Tomkins' household effects and stock. The *Taunton Courier* reported: 'It was a curious sight to witness some of the "Guys" in their motley dresses, covered with tinsel and spangles as active as any of the others.'

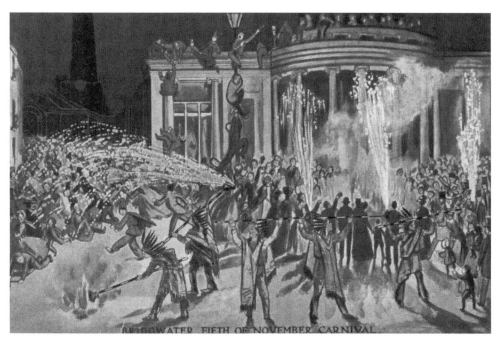

This postcard of the Fifth of November Carnival was sent from Bridgwater in May 1908.

The cause of the fire remained a mystery, but as it had broken out in a back room, a stray firework was immediately discounted. Both Mr Tomkins and Mr Smith were fully insured, but not so the landlord of the Temperance Hotel.

The *Taunton Courier* observed that the 'disaster naturally had a depressing influence on the demonstration'. The *Courier* further noted that the discharge of fireworks and the huge bonfire at the Cornhill was kept up with 'unflagging spirit and at about nine o'clock, the "Guys" paraded the town carrying the effigy of a certain foreman of some works who had rendered himself obnoxious to them'.

Bodysnatchers

Bodysnatching was a profitable business during the late eighteenth and early nineteenth centuries. Dead bodies were in great demand for dissection by the medical schools, surgeons, teachers of anatomy and such like, but the law forbade such practises other than on the bodies of executed criminals. Messrs Burke and Hare have gone down in history as being the most notorious exponents of this trade but hundreds of others were so engaged throughout the kingdom, either in small groups, or well-organised gangs.

The scourge of the bodysnatcher, or 'resurrectionists' as they were known, became so feared that the Church authorities and relatives who could afford it went to great lengths to protect the dead. Strong vaults and well-protected tombs were built and many graveyards were guarded by watchmen.

However, the occasional robbing of graves would appear to have been practised in earlier times. In 1658, in a case brought before the Somerset Quarter Sessions, one John Parker is reported to have broken into the grave of a Mr Hillard in the churchyard of St Peter and St Paul at South Petherton and took 'the string which goes from the brain to the heart for which his cousin Stuckey had promised him 12 pence'. The string was presumably the late Mr Hillard's spinal cord and may have been required for some potion or ritual associated with witchcraft or medicine. Sadly, the result of the case does not appear in the surviving records.

On Friday 30 March 1826, William Clark, alias William Taylor, appeared at the Somerset Lent Assizes in Taunton to face trial for 'stealing four dead bodies from the Church-yard of Walcot, in Bath'.

The court was told that Clark had confessed to being in the 'resurrection business' since he was six years old and claimed to have 'participated in the procuring of 2,000 bodies for anatomical purposes'. When bodies were scarce, the prisoner stated that he had been paid 10 guineas per cadaver. It also emerged that Clark had been tried on twenty-eight occasions for bodysnatching, but had only been found guilty on two.

Outlining the indictment, the prosecution stated that William Taylor and an unknown accomplice had rented a small house in a yard overlooking the Walcot burial ground: 'When people were buried, he and his accomplices were fully aware of the time, place and subject and they had acted with such industry and regularity, that between October and February, they had plundered Walcot burial-ground of at least 43 bodies.' Following enquiries, a hamper containing a body had been found and the prisoner's house had been searched. Three corpses were found here, packed up in hampers ready for despatch to London, and a fourth was discovered in a closet covered with straw. A large quantity of bones were found in the cellar being prepared to form a skeleton.

At the conclusion of the case for the prosecution, William Clark was allowed to address the court in his defence. He did not deny the indictment, 'but complained bitterly of the medical gentlemen not coming forward in his support as they had promised'.

The body of Sophia Bryer was taken from her grave in Cannington Churchyard.

On 5 April, the *Taunton Courier* reported that the jury found Clark guilty, but before the judge, Mr Justice Burrough, passed judgement:

> The prisoner begged very hard for mercy and said that subjects must be had for medical science. He drew some connexion between his profession and loyalty to the Sovereign for he assured the Court that when His Majesty (God bless him) had a complaint which rendered surgical operations necessary four *subjects* were required for a *preliminary operation* for the use of Sir A. Cooper, two of which, he (the prisoner) had procured.

Mr Justice Burrough, however, would have none of this, and sentenced William Clark to twelve months' imprisonment and levied a fine of £100.

Three years later, during the evening of Saturday 28 February 1829, a large hamper was delivered to the George Inn at Bridgwater for onward transmission to Mr J. Jones at Mr Hall's home at No. 41 Duke Street, Little Britain, London. The hamper had been brought across the town from the White Horse Inn at St Mary Street on a cart driven by Edward Baker, who said it contained wine in bottles. Later that evening, several men were moving the hamper when part of the bottom broke away and, to stop the contents from falling out, one of them put his hand into the opening – instead of bottles he felt a cold human foot. The hamper was opened to reveal a woman's corpse covered in straw and still wearing the clothes in which she had been buried.

The landlord, Jeffery Sutton, immediately notified the local magistrates and it was soon established that the body was that of thirty-eight-year-old Sophia Bryer, who had died in childbirth and was buried in Cannington Churchyard on Friday. The enquiries further revealed that the hamper had been brought to the White Horse by a Thomas Jones, who had since disappeared from his home in nearby Durleigh, although several

suspects were questioned. The surviving records are silent on the outcome. The next day Sophia was taken back to her grave by her husband and several friends.

Reports in the *Taunton Courier* on 18 March 1829 disclosed that around a month previously, a hamper had gone to London from Bridgwater on the Hero coach and left to be called for at the Castle & Falcon Inn. A few days later it was still there and had begun to smell. On being opened, the hamper was found to contain the body of a small boy around four years old. The *Courier* further disclosed: 'It has since been discovered that in the neighbouring villages of this town [Bridgwater] five bodies have recently been disinterred.'

In the absence of any further reports in the local newspapers, it would seem that no one was charged and no culprits apprehended.

A Sensational Capture in Bath

During the night of Thursday 13 February 1896, Henry Smith, a seventy-nine-year-old recluse and a rumoured wealthy miser, was brutally murdered during the course of robbery in his large home Muswell Lodge, at Muswell Hill, where he lived alone. For several weeks the police tried to identify the killers; it was established that there were at least two. Finally their enquiries identified two known burglars from Kensal Newtown, Albert Milsom and Henry Fowler. Both had been seen in Muswell Hill some 7 miles away on 13 February and a few days later were seen back in their usual haunts wearing new clothes, apparently somewhat affluent, and then the pair suddenly disappeared.

A toy lantern left at the scene of the murder was finally identified as belonging to Milsom's brother-in-law, and the hunt was on. The manhunt for the wanted men, now accompanied by Milsom's wife Emily and two infant children, led across the country from Liverpool to Bath, during which time the fugitives had joined up with a travelling showman by name of 'Professor' Sinclair and his wife, going town to town practising palmistry, fortune telling and similar 'entertainments'.

The hunt ended in Bath, where the travellers arrived on Easter Monday (5 April). Detective Constable Burrell of the Kensal Police, who was acquainted with Milsom and Fowler, had tracked them to Bath and to a doubled-bedded room above Mrs Emma Warren's small confectionary and general store at No. 36 Monmouth Street.

The murderers Milsom and Fowler spent several days walking around Bath before their sensational arrest.

On Saturday 10 April it was decided to act: Inspector Marshall of the Central Criminal Department, accompanied by Inspector Nutkins, the Divisional Inspector at Kentish Town (the district in which the murder had been committed) were despatched to Bath to effect the arrests. On their arrival at Bath early on Sunday morning they found Chief Inspector Noble, Inspector Newport and Detective Sergeant Smith of the City Force waiting to provide support.

Shortly after 10 p.m. on the Sunday evening, with the fugitives and their companions all in the room, the arresting officers, accompanied by Detective Burrell, made ready to move in. Several city officers were posted to cover the entrances and the six officers, each carrying a loaded revolver as it was believed that Fowler was armed, crept silently up the stairs. Assembling on the small landing, they made ready; finding the door unlocked and with revolvers drawn, they burst into the room shouting, 'Police - hands up!' Milsom, Fowler and 'Professor' Sinclair were standing by the fireplace in the dimly lit room and were taken completely by surprise. Inspectors Marshall and Newport went for Fowler, who reacted by launching a furious attack on the two officers, trying to fight them off to enable him to grab a revolver lying on the couch, upon which he had been sleeping. During the struggle Inspector Marshall received several heavy blows and suffered a badly bitten finger. Fowler was finally subdued and rendered semi-conscious by the inspectors raining blows on his head with the butts of their revolvers. Milsom was taken after a brief struggle by Chief Inspector Noble and Detective Burrell. A shocked Sinclair offered no resistance. Meanwhile, the two wives cowered behind the curtain that divided the room and the two infants, woken by the fracas, screamed in terror.

Milsom, his wife and children, together with the Sinclairs, were taken to the city's central police station and Fowler was transported to the Royal United Hospital where his injuries were treated.

Following questioning, the Sinclairs were released when it was established that Milsom and Fowler had given false names and the couple had been unaware of their companions' past activities.

A search of the room at Monmouth Street revealed a number of tools used for burglary, a loaded revolver and a quantity of ammunition.

On Monday afternoon, Mislom, his wife, children and Fowler left for London under heavy guard.

Following a sensational trial at the Old Bailey, during which both men claimed the other for the murder, and on one occasion the powerful Fowler attacked Milsom in the dock, both were found guilty and hanged at Newgate Prison on 9 June 1896 in company with William Seaman, who was sentenced to death for the double murder of a pawnbroker and his wife during the course of a burglary.

Tragedy at Pen Mill Station

On Friday 8 August 1913, the Great Western Railway's record-breaking locomotive *City of Bath* drawing the Paddington–Weymouth express slowly passed the starter signal set at danger on the approach to Yeovil Pen Mill Station and ploughed into the back carriage of the Paddington–Weymouth excursion waiting in the station at the platform. The excursion was running half an hour late and because the platform was not long enough to accommodate the main-line trains using it, the passengers in the last carriages had to wait until their train could be drawn forward to enable them to alight. Owing to the curvature of the lines, the drivers of the train down to Weymouth could not get a good view of the line in front of them when entering the station.

Although the brakes had been applied and the *City of Bath* was travelling at less than walking pace, the huge locomotive smashed and crushed the six compartments of the last carriage into a mass of splintered wood and twisted metal.

Mrs Louisa Redmond and Mrs Jane Legg were killed outright and eight passengers injured – several seriously; an unknown number, however, escaped unhurt. Tragically, one of the most severely injured, Miss Edith Groves, died a week later on 15 August.

Several professional local photographers were soon on the scene and within a short time postcards showing the crash were on sale. The following images were printed as postcards:

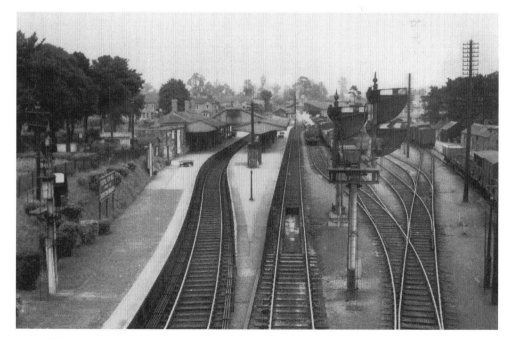

Pen Mill Station in 1913.

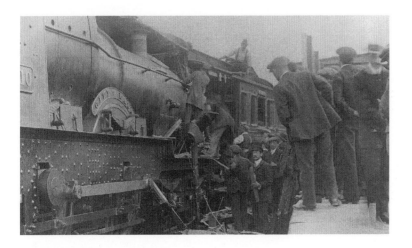

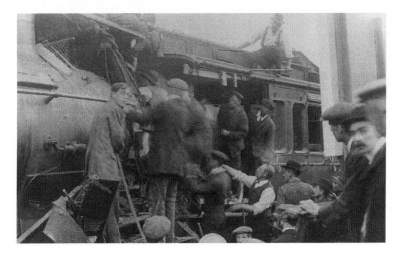

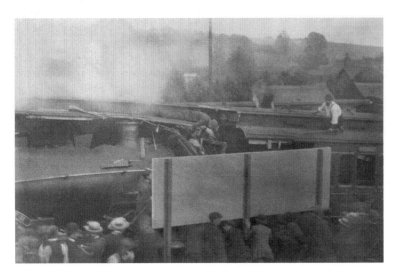

The rescuers
frantically
working to release
the victims.

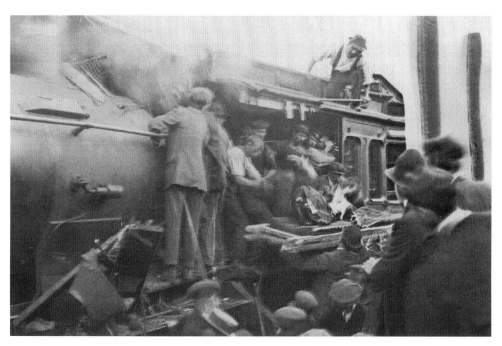

Removing one of the severely injured lady passengers.

Floral tributes on Miss Edith Groves' grave in Melbury Osmond Churchyard on the day of her burial.

In the Workhouse

The reports of the Board of Guardians of the Poor, who managed the Yeovil Union Workhouse in the mid-nineteenth century, can provide a glimpse into the world of Oliver Twist. For example, at a meeting of the Board on 21 February 1866, one of the guardians remarked on the disgraceful conditions he had found in the workhouse hospital. He called it a miserable place and, to laughter from his fellow guardians, exclaimed that he could not get the smell out of his throat for a week. There were no bedclothes and too many paupers were crowded into the room.

The chairman, however, disagreed, and said that he had visited the hospital just before the meeting and had found it 'quite clean'. Another guardian told his colleagues that he had been 'over the place a week ago and found it in a very good state indeed'.

However, at the next week's meeting, the chairman once again referred to the allegations about the condition of the hospital and stated that he deplored them. He concluded by saying, 'the Master of the House takes a pride in keeping it most daintily trimmed and neat.' And so there the matter remained.

In the following November a row broke out between the workhouse master and the schoolmaster, who taught the sons of the inmates. The schoolmaster wrote to the Board complaining of insinuations the master was making about him. He also complained that the boys could not get towels and their clothes were not properly cared for. The schoolmaster went on to write that he had been told by one boy that he had been in the workhouse since the previous April, but had only received one pair of trousers and these had never been washed. The same boy alleged that he had gone for a fortnight without a clean shirt. And on a recent occasion all the children had been only partly dressed for an entire morning and the boys had received just one towel each per week. The schoolmaster was brought before the guardians to explain his allegations and when asked how the boys dried themselves without towels, he replied that they used their jackets.

Several guardians refused to believe the complaints, and after he had left the room the master was summoned. He strongly denied the accusations and pointed out that ever since his wife, the matron, had been instructed to look after the girls, the schoolmaster had insulted her and thought nothing of shaking his fist in her face and calling her 'a damned liar'. This caused an uproar among the guardians, who were not used to employees recounting such language, but the master continued by telling how the schoolmaster had said that the matron could 'tell a lie as well as anyone else'. He went on to say that it was impossible for any boy to have gone so long without a fresh pair of trousers and only the previous week he and the matron had made all the boys nice and tidy out of the workhouse clothing stock. The master also denied that towels had not been supplied and the schoolmaster could have as many as he wanted, swearing on his oath he did not know of any being refused.

The matron was next and quite naturally backed up her husband, saying it was not possible for a boy to be without a change of shirt for a fortnight. The schoolmaster should have drawn his complaint to her notice.

The Yeovil Union Workhouse.

Next to be called was the boy concerned, who was 'cross examined in a gentle way'. The youngster confirmed the schoolmaster's allegations but was accused by the master and matron of being a liar. Two other boys were brought in, selected at random from the workhouse inmates, and said that they always had the same pair of trousers and one had had no change of shirt for two weeks. The master began to bluster and accused the boys of being 'tampered with', but they stuck to their stories and tearfully exclaimed that no one had spoken to them but their young friend. The guardians were convinced by the three youngsters, and the master and matron were censured for not having a regular system of washing and replacing old clothes. The guardians hoped never to hear any more such complaints.

The schoolmaster was recalled and the chairman told him that his complaints had been proved and the master and matron had been severely censured for their negligence. However, it was felt that 'he was more to blame than the Matron with respect to the shirt' and, as a teacher of morals, he was reprimanded for swearing at her. The Board hoped that 'there would be no repetition of these arguments and if he ever did such a thing again they would consider his removal'.

If you were unfortunate enough to be consigned to the workhouse, you could be forced to work and if you refused, you could be sent to the gaol.

Eight years later in September 1874, Jane Burt, an inmate of the workhouse, appeared before the Yeovil magistrates, charged with refusing to work and assaulting the master and the porter the previous morning.

The master told the bench the defendant had refused his order to go to her work and then refused to go to the workhouse cell as a punishment. He described how, after taking hold of her and dragging her to the door of the cell, she kicked him and bit his arm and hand. With the assistance of the cook, the master finally forced Burt into the

cell, where she began to kick the door and walls. Fearing she would damage the plaster work, he ordered her to remove her boots but she refused, so this was done forcibly with the aid of the porter and the cook. Grabbing one of her boots, the rebellious Jane hurled it at the master but it missed and hit the porter instead, cutting open is head.

After spending the rest of the day and night in the cell, Jane Burt was brought before the magistrates, who were told that she had been punished repeatedly for refusing to work but had continued to disobey all instructions. She was found guilty and sent to prison for fourteen days with hard labour.

A Loving Epitaph and a Dreadful Murder

Access to the compact sixteenth-century cruciform Church of St Martin at North Perrott, a design rarely seen in south Somerset, is through a square stone archway guarded by two yew trees. Adjoining the path that leads to the west door, there is a tombstone on which Ann Lane, who died at the tender age of twenty-one years on 27 February 1826, is lovingly remembered by the initials 'JT' and the following inscription:

> Hope of my life in early youth
> To thee this pledge I give
> Thy mind the seal of love and truth
> In mine shall ever live

But Ruth Butcher has no headstone or loving memorial in the churchyard, and it was said that the mound that once covered her unmarked pauper's grave in the east side under the low stone wall did not settle for many years. Today there is no sign of Ruth's last resting place but in-season wild flowers bloom in that part of the churchyard and provide a beautiful cover for someone who had little colour in her life.

Ruth Butcher was a single woman in her early forties who lived in North Perrott with her seven-year-old son John, where she earned a meagre wage working as a weaver in her cottage for a local firm and by taking in washing. She was rumoured to be of doubtful morals and a few years previously had been living in the Yeovil workhouse. Ruth also had a fourteen-year-old daughter away in service at Halstock.

On Monday 16 March 1874, Ruth Butcher was hungry and ill with a cough and a headache; she had no money and had been heard saying how she would like a piece of bacon. That evening, after tucking young John up in bed, she put on her bonnet and went out to meet a man who would supply that piece of bacon, but at a terrible price.

Ruth Butcher's body was found the next morning half-submerged in a small pond by Eli Symes as he drove Mr Rendall's cows into a field off Trendlewell Lane. The police were called and discovered she had been attacked in the lane by a man, who not only left his footprints in the mud but also the marks of his corduroy-clad knee. There was blood everywhere: along the lane where the body had been dragged to the pond, on the banks and hedgerows, and across the fields over which the murderer had fled, before finally disappearing near the vicarage in neighbouring Haselbury Plucknett. A large blood-stained stone was found near the body and Ruth's bonnet was also discovered tossed over a hedge. It had been partly burnt, as if the assailant had been using the bonnet as a light to search for a murder weapon, because some of the injuries had been caused by a sharp instrument and no such implement was found at the scene. Or, perhaps he was looking for something else that could be incriminating and did not find it, for in the pocket of Ruth Butcher's skirt a piece of bacon was found wrapped in paper and tied up with jute yarn, of the type used in local web making factories.

MIDDLE STREET, NORTH PERROTT

Ruth Butcher walked through North Perrott to her death on 16 March 1874.

There was a general outcry at the murder and its brutality. A reward of £100 was offered for the successful prosecution of the murderer, and a free pardon offered to any accomplice who turned Queen's evidence. There was much speculation about the motive for the crime; robbery was quickly ruled out as Ruth had nothing of value. The general conclusion was that she had met a man in the lane who had given her the piece of bacon for, as one local journalist wrote, 'an immoral return and the man and woman had quarrelled, the former had struck the latter, and having injured the woman more seriously than he intended, the murderer suddenly resolved to silence the only living witness to his brutality and beat her brains out with a stone.' There was, however, no sign of a sexual assault on the dead woman.

Although several men were questioned, the owner of the paper in which the piece of bacon was wrapped and the jute yarn with which it was tied was never traced and no one was ever charged with the murder, thus the killer of Ruth Butcher remained at large within the community and took the terrible secret to the grave

Ruth was laid to rest in an unmarked grave near the east wall of the churchyard of St Martin's on 20 March 1874 in a coffin supplied by the parish and inscribed 'R.B., aged 42, 1874.' Her two children were present, along with some fifty local women and children. It was reported that the young boy's clothing showed the wretched poverty in which the family lived, and his toes were seen poking through his worn-out boots.

Perhaps the earth over Ruth Butcher's grave did not settle in protest at her miserable life and shocking death in Trendlewell Lane – was it all for a piece of bacon?

A Slippery Tall Story

The Wonders of Nature and Art, published in 1780 and expressly designed as 'a useful and valuable production for young people', contained the following story:

> Sometime ago, in the last century, the farmers near Yeovil, whose fields lay contiguous to the river, suffered greatly by losing vast quantities of hay, for which several people were taken up on suspicion of stealing the same. What added to the surprise of every one was, that the hay did not appear to be cut, as it usually is, but pulled out, as if by some beast. But that appeared to be improbable, as several loads were lost in the space of a few nights – a circumstance so alarming to the farmers as to induce them to offer a considerable reward to any who could discover how their hay was destroyed. A company of soldiers quartered then at Yeovil – some of them for the sake of the reward – undertook to find out the affair.

The 'prodigious eel' emerged from its lair in the River Yeo to eat the farmers' hay.

They made their intention known to the people injured, who readily accepted the offer, and a night was fixed on to begin their watching in order to make a discovery. The appointed time came, and a dozen of the soldiers, after eating and drinking plentifully at the respective farmers' houses, went on their new enterprise with bayonets fixed and muskets charged, as to engage an enemy. They had not been long in ambush before one of them espied a monstrous creature crawling from the side of the river towards one of the stacks of hay. He instantly told his comrades. A council was immediately called, and they unanimously agreed that if the beast should devour any of the hay, two of them should fire at it from behind the stack, while the others dispersed themselves at different parts of the field in order to intercept it if it escaped their comrades vigilance. But the precaution was needless, for the soldiers fired their pieces with such dexterity that they soon laid the monster sprawling. This done, they all ran to see what was slain. But the moonlight not shining very bright, their curiosity could not be satisfied, though some of them said it must be the devil in the shape of a snake. Highly pleased with this exploit they hastened to the farmers and made known to them how well they had succeeded in their enterprise. Next morning all the neighbours round, with the farmers, the servants, and the soldiers, went to see this amazing creature, and to their no small astonishment, found it to be a prodigious eel, which it is supposed, not finding subsistence in the river, came out (ox-like) and fed on the hay. Its size was such that the farmers ordered their men to go and harness eight of their best horses, in order to draw it to one of their houses, which with difficulty they did. When they got it home, the soldiers desired leave to roast it, there being a large kitchen with two fire-places. This request was granted, and after cutting it in several pieces, and fastening each piece to a young elm tree, by way of spit, they put it down to roast. It had not been above an hour before the fire when there was as much fat run out of it as to fill all the tubs, kettles, &c., in the house, which put them under the necessity to go out to borrow. But at their return they found the inundation of grease so prodigious that it was running out at the key-hole and crevices of the door.

Down on the Farm

Looking across a peaceful Somerset landscape of fields, woods and farms, it is easy to forget that the countryside at work and play can be a dangerous place – sometimes lethal.

My first story warns against beating pigs, especially large boars with big tusks. On Monday 30 October 1826, eighteen-year-old Gabriel Chapple was driving some pigs out of the orchard at Voale Farm in Mark and, to hurry them up, he began to beat the large boar, who did not seem anxious to leave. This infuriated the hefty beast, which suddenly turned and attacked his tormentor. The assault was so quick that Gabriel had no chance to run and was badly gored by the boar's tusks, suffering a deep wound in his upper body, which broke two ribs, severely lacerated his lungs and ripped out some 2 feet of intestine before the enraged animal could be driven off.

A local surgeon, Mr Williams, was called and did what he could to treat the horrific injuries. The case was hopeless and Gabriel lingered in agony until the following Friday when he 'died of mortification'.

Mr Richard Caines, the coroner, held his inquest into the death of Gabriel Chapple on Sunday 5 November at Voale Farm, and the jury returned a verdict that 'The deceased died from the furious attack of a boar.'

Some six months later during the afternoon of Monday 30 April 1827, a twenty-one-year-old farm servant by the name of William Webber and several fellow farmhands were working at Ridlers Farm, near Dulverton, burning grass in a field called Santuary Hill.

At around three o'clock there was a sudden rumble of thunder, the sky turned black and a torrent rain began. The farmhands fled the downpour to shelter in the farmhouse but as William and Robert Hill prepared to join them there was a brilliant flash of intense light and a crash of thunder. Robert was thrown semiconscious to the ground and on recovering his senses stood up and looked around. A few yards away, he saw the dead body of William Webber: quite naked except for his boots, all his clothes torn and scattered about, and lying next to a hole around 2 feet wide and deep, surrounded by scorched grass. The horse that had been working with the party was stretched out on the ground, twitching next to a similar hole surrounded by scorched grass.

At the inquest into the death of William Webber held a few days later at Ridlers Farm, Robert Hill recalled the shock of the lightning strike and went on to describe how there was a wound on the back of William's head, blood was oozing from both ears, there were three or four red stripes down his back and a similar number of wounds in the feet. A watch was lying nearby with the enamelled face and works smashed and twisted. The iron nails on the soles of the deceased boots had been forced out and the leather uppers torn. Following Robert Hill's evidence, the inquest jury's verdict was 'Died by the Visitation of God'.

Young Joseph Osborne of Merriott was killed instantly when a load of wheat fell on him at Shuttern Oak Farm.

Sadly there was no hope that the horse would recover from the lightning strike and it was put down.

Now to Merriott in August 1831 and to Shuttern Oak Farm, where the farmer Roger French, assisted by Mr Harris, his father-in-law, and a lad, Joseph Osborne, were loading wheat sheaves onto a wagon. The loading was completed, a rope to secure the sheaves was passed over the top, where Roger French was standing, and Mr Harris and young Joseph began tightening it. The wagon was standing on a slope and suddenly the load began to topple over. Mr Harris managed to jump clear but Joseph was not quick enough, and the load of wheat rolled over him, breaking the lad's neck and killing him instantly. As the load began to topple, the farmer jumped for his life and survived with a fractured leg.

The inquest in the George Inn at Crewkerne returned a verdict of accidental death. The *Western Flying Post* reported that Roger French was recovering well and the horses harnessed to the wagon had not been injured.

On November 1857, the attempts by two men to save a third ended in tragedy at Mr Cox's large dairy at Rimpton in south Somerset. In the yard there was a large underground tank into which whey was piped from the dairy and then pumped into pig feeding troughs. On the fatal morning, the tank was being cleaned with carbonic acid and a ladder had been put down into the tank. George Cox, the dairyman's son, went down the ladder to start the cleaning but suddenly fell off. Seeing the young man fall, Silas Tuck scrambled down the ladder, but he too fell off and crashed to the bottom. Without hesitation, Henry Pardy began his rescue attempt, only to fall

unconscious to the bottom of the tank. A fourth would-be rescuer, Richard Warr, got halfway down but managed to climb back out before he was overcome by the fumes of the carbonic acid concentrated into a deadly gas in the tank's confined space. When it was safe to go into the tank, all three were brought out but pronounced dead by Mr Charles Jay, the Queen Camel surgeon.

The inquest returned a verdict of accidental death on twenty-year-old George Cox, eighteen-year-old Henry Pardy, and Silas Tuck, aged forty-two.

Fatal Foods

Old Thomas Courtney, who lived near Templecombe, had enjoyed the barley cake he had eaten for his dinner but after a short while he began to feel unwell. Thomas, at seventy five, had reached a good age for 1809 and his disposition was attributed, no doubt, to his advanced years. However, his condition soon deteriorated and he died in agony on 24 February.

During his final illness Thomas Courtney had lost his appetite, and some of the barley cake had remained uneaten. Food was too precious to waste, so the day after the old man died the remains of the cake were eaten by Jane Clarke and her three-year-old son John Culliford, who had lived with him. Six hours later and both were dead, having suffered violent sickness and agonizing stomach cramps – a dog who had been fed some of the cake was found dead too.

These fatalities were too much of a coincidence to be put down to natural causes, so the coroner ordered three surgeons and a physician to carry out autopsies on the three humans. Following their examination, the medical gentlemen were of the unanimous opinion that such was the state of the internal organs, the deaths were the result of a mineral poison, possibly arsenic, administered via the barley cake.

However, the coroner's inquest that followed failed to discover how the cake came to be impregnated with the poison and the jury returned a verdict of 'Wilful Murder' against some person or persons unknown. The Henstridge Parish Burial Register contains the following entry:

1 March 1809 Thomas Courtney 75
 Jane Clarke 53
 John Culliford Base born son 3
 These 3 last mentioned persons died by poison.

On 11 April 1824, eighteen years after the Yenston mystery, labourer William Hockey of Henstridge was brought before Mr Justice Park at the Somerset Assizes in Taunton, charged with administering a deadly poison to his wife Mary with intent to murder her.

The court was told that on the morning of the 14 March previous, a most unusual thing had happened: William Hockey had laid out the breakfast and made tea for the family. However, he had refused to drink the tea (another unusual thing) and had left the room to get ready for work. After drinking two cups of tea, Mary was taken violently ill and the local doctor was called. When told of the circumstances, the medical gentleman's suspicions were aroused, then later confirmed when he found traces of arsenic in the cup his patient had used. William Hockey was arrested and sent for trial.

However, Mary Hockey was most unwilling to incriminate her husband in her statement, and said that he had always behaved well towards her. She went on to say that their house was infested with mice and her husband had bought some poison to kill them; this was confirmed by the local druggist, who stated that William Hockey

Templecombe

In 1809 three people died from possible arsenical poisoning near Templecombe.

had bought the arsenic quite openly. Perhaps, it was suggested, the tea cup had been used to mix the arsenic and had not been properly washed out.

William Hockey was found not guilty but, before he was allowed to leave the dock, Mr Justice Park had a few words to say to him. The judge said that he had had a very narrow escape and owed it to the humanity of the jury. Although it could not be obtained from his wife, who had evidently screened him and therefore could not come before the jury, the learned judge noted that it appeared in the depositions (which were not disclosed in the record) that he had been a most cruel and rough husband. Indeed on one occasion he had left his wife and the country, and since his return he had never treated her in a becoming manner. If the jury had pronounced a guilty verdict, Mr Justice Park stated that his life could not have been saved and he had better reform his conduct and thereby save himself from an ignominious end.

No doubt with the judge's comments ringing in his ears, a very relieved, and perhaps chastened, William Hockey returned to Henstridge – let us hope he treated Mary in a more 'becoming manner'.

A Few Municipal Moments

At the quarterly meeting of Taunton Town Council held on 11 August 1896, Alderman Spiller presented the report of the committee responsible for the town's sanitation and drainage, remarking that at the previous week's committee meeting Councillor Standfast had called the members 'a lot of fools and idiots'. The councillor had also accused the members of proposing to buy land from their friends and were going to get 'a big haul' out of the deal. Alderman Spiller stated that he had been shocked and upset at the language and of course there was no foundation in the accusations.

Councillor Webber supported the alderman and recalled that Councillor Standfast's words were: 'What do we find! They said there was land to be had in every position, and then they bought land for the benefit of their friends, and rob the poor. The committee must be fools to do it!' Because of this disgusting language, Councillor Webber wished to be relieved from serving on any committee with Councillor Standfast.

Councillor Standfast retorted that it was very fine for Councillor Webber to say that he had called the members fools and idiots, but that very councillor had threatened to screw his nose out of his face! He went on to shout over the cries of 'order' that Councillor Webber had indeed uttered this threat, and he defied anyone to deny it. This brought an immediate reply from the said Councillor Webber, who threatened to horsewhip Councillor Standfast!

Councillor Standfast was a controversial member of Taunton Borough Council in the late 1890s.

Fearing the meeting would descend into chaos, the town clerk said quite bluntly that Councillor Standfast had indeed called the committee fools, idiots and rascals. This intervention by the respected chief official silenced the outbursts and despite some mutterings, normal business resumed.

Just over two years later, the redoubtable Councillor Standfast was the subject of the editor's comment column in the *Taunton Courier* of 21 December 1898:

Notes From Our Observatory
The Bridge, Taunton

Another field day at the meeting of the Taunton Town Council on Tuesday with the usual guerilla sort of warfare. The old tactics were once again displayed, 'you're another', and so forth. We have of late, lost sight of our old friend Mr. Standfast, though we are glad to know that he is good health, and remains as energetic as ever. He has now taken to a form of pedestrian exercise during the meetings of the Council, consisting of a speedy exit from the Chamber, and as speedy a re-entry. In theatrical parlance it may be said that he is an all round artist – a man who can and does play many parts. On a previous occasion Mr. Standfast left the room in high dudgeon, and he stayed away for so long that the proceedings without his presence absolutely fell quite flat. On Tuesday after a little skirmishing with the mayor, he again hastily gathered up his papers – which it said consist of electric light statistics, comparison of rates, &c. – and beat a hasty retreat. Whether the mace-bearer (who remains outside) reasoned with him is not known. Whether he reflected on the thought that 'the way to procure insults is to submit to them' is also uncertain. But this much is certain, having left the room remarking 'I'm not going to be insulted by him (the Mayor),' he shortly afterwards returned and continued to add his valuable advice in subsequent discussions. Possibly he could not submit to the jeering refrain of 'Now we shan't be long,' uttered by Mr. Perkins in connection with this little, one of several, lively scenes. Never mind, Mr. Standfast is a bold fighter, and even when he is hopelessly wrong he fights on, Napoleon as we all know, dearly loved such a man.

In the early 1900s Yeovil Borough Council had a great problem with the quality of the sewerage pipes bought by its borough surveyor, and the long-running arguments over this question dominated meeting after meeting.

During the winter of 1902/03 pipes were being laid from the Pen Mill Sewage Works to the town, when a number suddenly collapsed due to defective construction. As a result, the battles in the council chamber became fiercer, and at the March meeting the mayor reminded members that there were such things as standing orders and what was their use if councillors would not abide by them. The mayor added that in future he intended to be more strict with members and hoped that he should not 'have the misfortune of falling upon them, whether Alderman or anyone else.'

The council obviously took no notice of this request because after a two-hour debate on the pipes question, it was reported in the *Western Gazette* that the meeting became very disorderly. The standing orders were readily forgotten, several members were speaking at the same time, and everyone seemed to be very confused. Such was the bewilderment that Councillor Hayward voted against his own proposition and only realised his mistake after Councillor Bradford shouted 'Why are you voting against your own resolution? What's the matter with you!' Councillor Hayward's proposal that

the defective portions of the sewer should be relaid in concrete was lost by a majority of one, presumably by the vote of its proposer! The war would continue for several more years.

Back in the previous December, Councillor Hayward had been in trouble with the mayor when, as a newly elected councillor, he had attended his first council meeting and had taken a seat near the top of the table alongside the borough officials. The mayor, in no uncertain terms, pointed out to the new councillor that it was the custom of many years that 'the gentleman last elected should sit at the lower end of the table.' Councillor Hayward then took his proper place at the far end of the table.

Boating Tragedies

What better way to spend a warm, sunny summer's day than on a boat trip? One such day was Friday 30 July 1840, when Bridgwater baker, Mr John Marler, took eight young friends, two gentlemen and six ladies in two boats from Burnham to Gore Sands, which, when exposed at low tide, were considered to be a pleasant destination for an excursion. (The -On-Sea was added later because there are several other towns named Burnham in England).

At around four o'clock it was time to leave as the sands would soon be covered by the incoming tide, and the excursionists clambered back into the boats; Mr Marler and four of his friends, including Miss Mary Ann Ackland and her companion Miss Hurford, took their seats in the larger boat and the rest boarded the smaller.

The boatman raised the sail of the larger vessel and, with the smaller in tow, set out for the return cruise to Burnham. Suddenly, with no warning, out of nowhere came a squall of wind and with no time to trim the sail and with equal suddenness, the boat keeled over and capsized. Mr Marler, his four companions and the boatman were precipitated into the water and were struggling for their lives. Despite being in tow, the smaller boat remained upright, and eager hands reached out and hauled their desperate friends and the boatman to the sides where they clung on for dear life. Seeing

THE SANDS, BURNHAM-ON-SEA. 22341.

The body of Mary Ann Ackland was found on the sands of Burnham, four days after she was drowned when Mr Marler's boat capsized.

a fishing boat around half a mile off, those who could began shouting for help and waving frantically. The fisherman, returning to Burnham after retrieving some nets lost the evening before, heard the cries and went to rescue them. He arrived just in time to help pull the exhausted survivors and a semiconscious Miss Hurford into both boats. Where, however, was Mary Ann Ackland? The twenty-three-year-old daughter of Taunton ironmonger Mr Thomas Ackland had disappeared and, sadly, had to be presumed drowned.

Mr Marler and his surviving companions were brought ashore at Burnham and, despite the fears for Miss Hurford's life, this was saved by a local doctor's prompt medical attention. There would be no further sign that day of Mary Ann, other than her small embroidered handbag found on the beach.

After four days, the sea finally gave up the body of Mary Ann Ackland when it was found on the beach not far from where the boat had capsized.

Some eleven years earlier on Tuesday 30 June 1829, a fine summer's day, seven friends (all Bristol tradesmen) set sail down the River Avon on an excursion to the small island of Flat Holm in the Bristol Channel. Steering the boat, described as a 'narrow sharp pointed boat called a Norway boat', was its owner, twenty-one-year-old George House, who until recently had operated wherries on the Bristol Floating Dock.

After spending a short while on Flat Holm, it was time for the 'party of pleasure' to leave for home, but the calm conditions of the morning's cruise had been replaced by a rising breaking sea. However, George House was undeterred and the party set sail back up the channel in the rapidly deteriorating weather.

Shortly after leaving the Holm they were met by a Bristol Channel pilot returning to port, who after seeing the state of the weather and fearing the inability of the small Norway boat to stand a heavy sea, hove to and offered to take the party on board his sturdy pilot cutter and secure their boat. However, the offer was declined, which turned out to be tragically fatal.

When George House and his friends had not returned home as planned by late evening, fears began to be expressed for their safety, and when on the following morning there was still no sign of the boat or its occupants, the worse was feared. For over a week there was no news of the party and searches along the coast were fruitless. However, the fears that the boat had been overwhelmed by the rough sea turned into a reality when, on Thursday 9 July, a body was washed up on the beach at Clevedon. The watch found on the corpse was identified as belonging to George House by his mother.

On Friday 10 July, on the Welsh side of the Bristol Channel, the missing boat was found washed up on the beach by the village of Goldcliff, and nearby was the body of another of the doomed excursionists by the name of Coles.

On the following day a third, and much-decomposed, body was found by some boatmen off the mouth of the River Avon and brought to Bristol. It was identified as George Thorne (a butcher of Temple Street) by his wife, who recognised that the laces of the shoes still on the corpse were those of her husband.

During the following weeks two more bodies were found and identified: thirty-one-year-old William Evans was found at Portishead, and Joseph Gillmore was found on the beach near the village of Kingston Seymour. The bodies of the two remaining missing friends were never found.

A Fatal Trap Accident

At around 10.30 p.m. on the evening of Monday 27 July 1891, Edward Wilkins was riding home from Sherborne to Yeovil's Castle Hotel, Middle Street, but as he descended Babylon Hill he heard a man's voice calling for help. Dismounting, he could just make out the figure of a man in the darkness, leaning against the roadside bank. Coming closer, he recognised James Gill, who pointed to a dark shape lying in the road and exclaimed that it was a dead man. Bending over the recumbent figure and in the flickering light of a match, Edward Wilkins saw that the man lying on his face was unconscious but still breathing. Kneeling closer, the landlord also recognised him as William Harris, a local auctioneer, and turning to James Gill asked what had happened. James replied that, together with his wife Lucy and the auctioneer, he had been travelling down Babylon Hill when the horse pulling the trap in which they were riding suddenly bolted, the two men were thrown out, and the horse galloped off down the road with Lucy Gill still in the vehicle.

William Clode, who was driving an empty carriage from Sherborne back to the Choughs Hotel in Yeovil, arrived on the scene and offered to help. Leaving William Clode to stay with Harris and Gill, Edward Wilkins remounted his horse and galloped off down Babylon Hill to summon medical assistance. As he was approaching Yeovil Bridge, his horse suddenly swerved around an object in the road and stopped.

Edward Wilkins was riding home to the Castle Hotel in Yeovil when he came across the trap accident.

Dismounting, Wilkins found it to be a woman, and by the light of a match recognised Lucy Gill; she was unconscious and he dragged her to the side of the road before setting off again to get a doctor.

Meanwhile, James Gill decided not to await the attendance of a doctor but take his friend on to Yeovil for treatment. With the help of William Clode, he lifted the insensible auctioneer into the carriage and laid him on the seat. As they neared Yeovil Bridge, the carriage horses shied and the two men made out the shape of a woman's body lying at the side of the road. Fearing the worst, James Gill leapt from the vehicle and, recognising his wife, tried to revive her but without success. With no room in the carriage for another recumbent passenger, Gill instructed Clode to drive as fast as he could to William Harris's home in Bond Street and he would await the arrival of medical assistance with his wife.

Doctor Ptolemy Colmer, called out by Edward Wilkins, set off on horseback from his house in South Street, but had not gone far when he met the carriage conveying the unconscious William Harris and after examining the auctioneer returned with him to Bond Street. However, finding he could do nothing to aid immediate recovery, the doctor set out for Babylon Hill, where he found the Gills waiting at the side of the road.

Lucy Gill was still unconscious. The doctor's examination revealed a deeply cut face, severe abrasions to her head and a possible fractured leg just above the ankle. From the torn and dusty state of her clothes, Dr Colmer concluded that Lucy Gill had been dragged some distance along the road. After stitching her face, the doctor examined her husband and, apart from a cut on the back of his head, James Gill was in good shape.

News of the accident had brought a horse and cart to the scene, and the Gills were conveyed to Yeovil Hospital. Doctor Colmer returned to his patient in Bond Street and carried out a more detailed examination of the unconscious man. William Harris was found to be suffering from severe bruising to the back of the head, bleeding from one ear, and the doctor concluded that there was an extreme fracture at the base of the skull – recovery was unlikely. For Dr Ptolemy Colmer, it was going to be a busy night, because he then went to the hospital to examine the Gills and treat their injuries. One thing Dr Colmer noticed, however, was that all three smelt strongly of liquor.

William Harris died at 12.30 a.m. on Tuesday and the inquest into his death opened on Wednesday 29 July in the Rising Star Coffee Tavern. After taking evidence from several witnesses, including Henry Slade, from whom William Harris had hired the horse and two-wheeled trap, the jury found it difficult to establish what had happened. The horse, still harnessed to the trap, had returned to its stable of its own accord but Henry Slade had found the offside wing board and rails had been knocked off. However, as the only witnesses to what had happened were dead or in hospital, the inquest was adjourned for evidence to be given by James Gill, who was expected to recover within a few days.

Doubts were being raised on the cause of the accident and the rumour mills were turning. Miss Louisa Harris, whose journals were edited by Miss Jean Harper and published by the *Western Gazette* in 2003, wrote on 29 July that the affair was involved in a good deal of mystery and much speculation, plus a few hints of foul play. Could there have been a fight or struggle in the trap resulting in the two men falling out and breaking the rail and wing in the process? At the moment everything was speculation.

On Sunday 2 August Mrs Lucy Gill died from the effects of concussion, exhaustion and septic infection. The inquest, when it reopened in the Red Lion Inn on Thursday 6 August, was now investigating the deaths of William Harris and Lucy Gill.

After hearing the medical evidence, the next witness was Edward Green, the post boy at the Antelope Hotel in Sherborne, who testified that he had seen William Harris leave the hotel sitting between the two Gills in the horse trap, and the seating was a 'tight fit'. William Harris was driving and they all appeared to be very friendly and sober.

Arthur Field, a gardener, testified next. He stated that he was helping an Irishman drive six colts from Sherborne Fair to Pen Mill Station during the evening concerned, when a small trap with three passengers passed by and then stopped. Two men had got down and when the witness enquired what was wrong, he was told that the trace had come off. No one could provide rope or string to effect a repair, but one of the men produced a pocket handkerchief and tied the trace. The repair to the trace was confirmed by Henry Slade, who found a handkerchief tied from the harness to the front part of the trace.

The jury then adjourned to the hospital and James Gill gave evidence from his bed. He said that he had met William Harris by appointment at the Sherborne Horse Fair between five and six o'clock, then, accompanied by his wife, they had visited several hotels during the evening. However, he could not recall whether they were sober. When they left Sherborne, James Gill could remember that he was sitting on the near side of the trap, his wife in the middle, and William Harris on the off side driving the horse; he recalled that it was a very tight fit. He could remember little of the journey back to Yeovil; he could recall something snapping, but had no memory of falling from the trap or how he came to be on the road. He could remember, however, the doctor 'sewing up his wife'.

Following James Gill's evidence, the jury returned to the Red Lion Inn where the deputy coroner reviewed the evidence, remarking that the movements of the deceased in Sherborne were reasonably clear, but thereafter not so. Gill's evidence of the seating arrangements differed from other witnesses but he had little memory of the journey. In the deputy coroner's opinion, the jury might consider it reasonable to conclude that the deaths of the two persons concerned were accidental.

The jury returned a verdict of accidental death in both cases, caused by falling from a trap.

Crime in Ilminster

A Swindler

From the *Taunton Courier* of 30 January 1817:

> A woman of decent appearance on Wednesday week, visited different shops in the town of Ilminster, at each of which, she purchased some trifling articles, which she paid for, as well as her expense of chaise, &c. at the Inn, by changing 10l. [£10] local notes. In this manner she passed four 10l. notes at Ilminster. It has since been discovered that she proceeded in the same way of doing business at Somerton, Langport, South-petherton, &c. She posts expeditiously from town to town, and makes but a short stop at each place, merely to visit different shops, and change her notes. It is reported that a gentleman from Wells Sessions, lost a parcel of bills to the amount of £400, on leaving the coach a moment to go into the Inn; on his return, the parcel was missing, together with one of the passengers; so that there is strong grounds of suspicion, that the notes lost are circulating by this woman.

A Thrilling Chase

Shortly after noon on Wednesday 30 May 1934 (117 years after the previous story), a well-dressed stranger walked into the Ilminster branch of the Westminster Bank and presented a cheque for £97 cash (worth several thousand pounds at today's value), signed on the account of Mrs Alice Chetwode, the sister of the late Colonel Vaughan Lee of Dillington Park. The cheque appeared good, but because the lady had not lived in the neighbourhood for some years, and the customer was not known to the cashier, his suspicions were aroused that all might not be as it seemed.

The cashier asked the customer to wait for a few moments while he examined the signature and because he was not known, he would consult his senior colleague. The stranger then excused himself and left the bank, stating that he was going to park his car.

Suspicions were now confirmed and one of the clerks was despatched across the road to the police station. As Police Sergeant Morris left the station in response to the information, he saw a man matching the description walking away down East Street casually smoking a cigarette and shouted 'Stop that man!' With this the suspect started to run and at the same time took up the cry of 'Stop that man!' Shoppers and passers-by, confused by the shouting, made way for the fugitive, no doubt under the impression that he was also in pursuit – no attempt was made to tackle him!

Running into and along Silver Street, the suspect made for a powerful blue Chrysler Saloon parked opposite the entrance to the parish church and as he opened the passenger door and got in, the driver started the engine and the vehicle accelerated away. Speeding and weaving from side to side along Silver Street, the Chrysler smashed

into a grocer's handcart, scattering its contents all over the road and losing a near-side hubcap in the process.

The redoubtable Sergeant Morris continued the chase on foot along Silver Street until he lost sight of the car disappearing towards the Taunton road. Rushing into a nearby motor garage, the sergeant telephoned the County Police HQ in Taunton, describing the vehicle and the alarm was transmitted to police stations across Somerset. Patrol cars and police motorcyclists were soon out scouring the countryside but the culprits had eluded them.

A description of the wanted man was quickly circulated: 'Age 26 to 35 years, 5 feet 10 inches high, dressed in navy blue suit, grey trilby hat, black shoes'. The car was a blue Chrysler bearing a Bradford, Yorkshire registration number KW 6898 and missing a hubcap from one of the near-side wheels.

It would seem that the two malefactors had made good their escape and were never captured, at least not here in Somerset.

SILVER STREET ILMINSTER

The suspect fled from the Westminster Bank along Silver Street.

Theft, Forgery and Fraud

Hanging for the crime of forgery was abolished in Great Britain in 1836 and for theft by the following year, but this came too late for Arthur Baily and Charles Hibbert, who ended their days on the end of a rope at Ilchester.

Arthur Baily was born in the Devonshire town of Ashburton and led a seemingly blameless and honest life for thirty-seven years, until 1810. As a young man he had come to Bath and took employment as a clerk with Mr Price, the city postmaster, with whom he had 'conducted himself for seven years with great assiduity, and to the perfect satisfaction of his employer'.

In 1802 he resigned his position, got married and became the landlord of a public house at St James Street in the city, followed by the purchase of the Fox Inn at Midford. The marriage produced six children and Arthur Baily continued to find a good friend in Mr Price, who welcomed him to take meals with his clerks and servants whenever he was in Bath.

During the times when the post office was especially busy, Mr Price employed his former clerk to help in sorting and stamping letters and 'Here the temptation of purloining valuable letters presented itself and he was led to commit the crime for which he justly suffered', so reported the *Taunton Courier* of 19 September 1811 on the execution of Arthur Baily at Ilchester.

And what was the crime for which Arthur Baily 'justly suffered'? On 11 December 1810, a letter containing valuable money drafts and post bills, the property of Messrs S. and W. Slack (linen drapers of Bath) and addressed to their London bankers, Messrs Whitehead, Howard & Co., went missing. Although Arthur Baily was not the first suspect, lengthy enquiries found that one of the stolen post bills had been used to buy a watch at a jeweller's in London and the shopkeeper identified Arthur Baily as the purchaser. It was also established that he had deposited some of the bills at the General Post Office. The trail led to Gosport and, finally, in early June 1811, to the Fox Inn at Midford.

Arthur Baily appeared at the Somerset Assizes two months later, indicted for 'Having feloniously stolen from the Post-office in the city of Bath, a letter containing various drafts of money, and Bank Post Bills, the property of Messrs. S. and W. Slack.' He was found guilty, sentenced to death and taken back to Ilchester Gaol to await his fate. It was during those final days that the governor, Mr William Bridle, showed the prisoner a list of letters reported to have been lost or stolen from the Bath Post Office and enquired if he might know about them. Arthur Baily, however, maintained that the only letter he had taken was the one for which he had had been convicted and continued to so deny until the end. This took place at 8 a.m. on Wednesday 11 September when the condemned man was placed in the back of a cart and, followed by a large crowd, driven to his place of execution on the Gallows Five Acres field just outside Ilchester on the west side of the Yeovil road. Arthur Baily's execution was last on the Five Gallows Field; thereafter, all executions were carried out at the gaol.

In August 1819 Charles Hibbert was brought before Baron Granam at the Somerset Assizes, indicted for 'Having forged and counterfeited a plate of copper purporting to be a Note of the Governor and Company of the Bank of England'.

From the evidence it appeared that Charles Hibbert came from a much-respected family of engravers and copper plate printers who had been in business in Bath for nearly a century, but by his own admission he confessed to having been of 'idle habits' and had fallen into extreme poverty and crime.

According to the prosecution, forged £1 notes of Messrs Tylee, Salmon and Co.'s Devizes Bank had been circulating in the city and extensive investigations by the Bath Police led to a 'disorderly house' kept by Thomas Dowell and his wife Elizabeth at the back of American Buildings, Walcot, also known as 'Botany Bay'. The police raided the establishment and discovered several worn-out plates: a plate on which the Devizes notes had been printed, and some unsigned notes of the Banks of England and Ireland, together with the plates upon which they had been printed.

Charles Hibbert was arrested along with the Dowells, but only Hibbert sat in the dock; the Dowells had turned King's evidence against their partner in crime and were released.

The evidence was overwhelming and Charles Hibbert was found guilty and sentenced to death. On 11 September 1819 at 10.30 a.m., he slowly and with difficulty climbed the steps up to the gallows where he continued in prayer with the prison chaplain. The *Taunton Courier* described the scene:

> The executioner then proceeded in his sad office and everything being prepared, on Hibbert having being left to himself, he called to Mr. Bridle (the humane governor of the county gaol) in a hurry, saying he should fall, as his head became giddy, and having only one leg, he begged to sit down a while: his firmness forsook him, for the first time, he was in great alarm and agony of mind: hassocks were brought from the chapel on which he sat down from whence, at about 20 minutes

The Pump Room and Bath Abbey would have been familiar scenes to Arthur Baily and Charles Hibbert.

before 12, he rose and fell never in his life to rise again! The executioner having proceeded in his sad office, so for that nothing, but falling off the drop remained to complete the career of this unfortunate man; he died without a struggle.

One hundred and thirty four years later, Lieutenant General Anthony Edward Shaw, an elderly bachelor with an impressive war record, could be considered quite a catch and the widow with whom he lodged in Yeovil willingly accepted his proposal of marriage. It was no problem, therefore, to obtain credit of £2 11s from Templeman's shop in Yeovil, a £10 note from the Midland Bank and £140 from the widow.

However, the elderly bachelor was no lieutenant general. He was in fact Ernest Raymond Harper, of no fixed address, when he appeared at the Salisbury Quarter Sessions in April 1953. He pleaded guilty to a series of false pretences in Wiltshire and Somerset, including taking the widow's £140, along with a string of similar offences in Yeovil and Crewkerne. It was also divulged that Harper, as well as masquerading as a captain, major general and lieutenant general, had also styled himself Lawrence of Arabia. When challenged that Lawrence had been killed in a motorcycle crash, Harper argued that he was Lawrence and the man killed had been his double. It was also disclosed that Harper had received eleven convictions for fraud since 1931 and one for bigamy, and had spent twelve years in prison. The medical examination concluded that the prisoner was sane and the sixty-two year-old rogue was sentenced to seven years' preventive detention.

A Dastardly Outrage

The general election of 27 January 1910 was a hard fought one, especially in the Liberal stronghold of the Yeovil Division where Sir Edward Strachey had been regularly returned to Parliament since 1892. Sir Edward's Conservative opponent, the Hon. Aubrey Herbert, reduced the Liberal majority from almost 2,000 at the 1906 election to 511, and in the 1911 by-election following Sir Edward's elevation to the peerage, the Conservative's would win the seat.

The poll in Yeovil on that day in January 1910 was the heaviest ever, and it was reported that by midday well over two-thirds of the electorate had voted – however, the adult franchise was much smaller than today and most women were denied this fundamental right. The total turnout was 90 per cent, with one Conservative travelling all the way from Rome to vote, and a Liberal voter was said to have journeyed from Holland. During the evening, large crowds of supporters cheered and counter-cheered in the Yeovil streets but there were no reported incidents of trouble between them. On the eve of polling, the Liberals had processed through the town behind a brass band, said to have played just one tune because it knew no others. The crowd was followed by a legion of small boys bearing the party red, and shouting as only small boys can. At the tail of this 'hullabaloo' was a carriage drawn by two horses in which Lady Strachey sat, accompanied by Mr C. W. Pittard. In opposition, the Conservatives held a rally in the Princes Street Assembly Rooms, where the floor and stage were filled with enthusiastic supporters singing the Tariff Reform song and cheering speeches by local dignitaries.

During the evening following the declaration of the result the Conservatives, buoyed up by their good showing, held a demonstration in the Assembly Rooms in Princes Street where they were addressed by the Hon. Aubrey Herbert. Many partisan songs were sung and speeches made after which everyone went noisily home through the streets.

What happened later that night was reported the next day by the *Western Gazette* under the headline 'A Dastardly Outrage'. The indignant townsfolk were told that late on Thursday night, following the Conservative demonstration in the Assembly Rooms, one of the plate-glass windows of Messrs Price & Sons' showroom that adjoined the Constitutional Club in Princes Street was damaged, apparently by a bullet. The hole on the outside of the glass was the size of a miniature rifle bullet and the piece punched from the inside was found 42 feet away at the back of the showroom, which indicated that the bullet had been fired from a high-velocity weapon. The missile had grazed a showcard and ricocheted off a pillar but a detailed search failed to locate the bullet, which had probably disintegrated.

The experts called in to investigate were firmly of the opinion that a bullet had been fired and the height of the hole and the direction of flight indicated that it had been discharged from a passing vehicle, the noise of which would drown the shot, accounting for no one reporting the incident. Mr Priest, the shop manager, stated that he had heard nothing and noticed nothing when he closed down late that evening.

Was the Constitutional Club the intended target?

The *Gazette* reported:

A significant fact is that the window is next to the Conservative Club, and it is freely suggested that the shot was put through the shop window in mistake for that of the Club. If fired intentionally, and it is difficult to say how it could have been an accident, it was a dastardly thing to do, as the force behind the bullet was sufficient to have instantly killed anyone in its path.

The culprit was never found.

Lion Kills Man

During the week commencing Sunday 11 February 1827, Mr Rochester's 'Menagerie of Wild Beasts' was quite an attraction at Bedminster outside the Star Inn and no doubt many came, especially to see Nero the Lion.

Nero, it seems, was somewhat famous for his very docile nature; not long before his appearance in Bedminster, he had refused to fight a pack of dogs sent to attack him at Warwick. Indeed, since the show opened outside the Sun Inn, it was reported that several men, women and two children had accompanied the keeper into Nero's cage.

Mr Rochester had lost the services of an assistant keeper and had let it be known in the area that he was looking for a replacement. Joseph Kiddle, originally from Sherborne, had just arrived in Bristol from Exeter. Having heard Mr Rochester was looking for an assistant, he had travelled over to Bedminster on Thursday 15 February and offered his services. The twenty-five-year-old informed Mr Rochester that he was accustomed to the care of wild beasts and was taken on.

Joseph's requests to go into Nero's cage were refused, but later that afternoon he was left for a short while in sole charge of the menagerie. The new assistant's job was to show the wild beasts to the paying public, who naturally expected to see the beasts 'being wild'. However, Nero was not 'being wild' and was fast asleep at the back of his cage. This was not what the hard-earned pennies had been paid for, and all of Joseph's efforts to rouse the sleeping beast from outside the cage proved fruitless. Rashly, and as it turned out, fatally, Joseph opened the door of the cage, went in and, after carefully closing it, approached the apparently slumbering lion. The young man probably never really knew what happened next, as Nero, possibly startled by the appearance of a strange figure (and also hungry) reverted to being a 'wild beast' and sprang at Joseph, hit him with a violent blow on his chest with his huge paw and clamped the victim's head and neck in his massive jaws. Blood spurted from Joseph's severed carotid artery as the lion's biting jaws broke his neck; he died within seconds with no apparent suffering, according to the *Bristol Mercury*.

The audience looked on in horror and then there was chaos as they fled the scene. As the shouting and screaming spectators poured out into the street, a local resident who happened to be passing ran to his house and returned carrying a pair of loaded pistols and another called a local blacksmith who arrived with red-hot iron bars drawn from his forge. The *Bristol Mercury* reported that Nero crouched with one of his paws on the breast of the corpse and was said to have been kept back from tearing it apart by the red-hot irons being thrust at him through the bars. Finally, the thrusting hot irons forced Nero to give up his prey and he backed away.

Now came the gruesome task of extracting the corpse. This was achieved by inserting some planks of wood through the bars of the cage between the body and the lion, which was kept back by prodding with more red-hot irons. Finally the door was opened and the bloody body of Joseph Kiddle pulled out.

Nero, possibly because he had lost his prey or was hurt from injuries sustained from the hot irons, was reported by the *Bristol Mercury* to have 'Lashed his sides with his tail

Waking a sleeping lion in his cage can prove fatal.

and sprang around his den with great force. He continued in his disturbed and violent state till midnight; since when he has resumed his usual peaceable demeanour.'

The tragedy had happened at around 5 p.m. on Thursday but Somerset coroner Mr Richard Caines was not summoned from his home in Langport until a letter was sent at 8 a.m. the next morning.

When he arrived at Bedminster on Saturday morning, Mr Caines immediately empanelled his jury and the inquest on the body of Joseph Kiddle was held in the Star Inn. The terrifying events of that Thursday afternoon were recounted, witnesses were called and the jury returned an immediate verdict of 'accidental death'.

There is a sequel, though, to these events. The day after the frightful events of Thursday, Mr Rochester's 'Menagerie of Wild Beasts' reopened and the crowds returned. Then, in its Monday 19 February edition, the *Bristol Mercury* continued the tale:

In this exhibition on Friday last, while a number of respectable persons were in the Menagerie, the keeper was exhibiting a fine Leopard, which on account of its tameness, he lets out in front of his cage. The Hyena in an adjoining cage flew towards the Leopard, who turned upon is assailant. The keeper interfered when the animal threatened an attack on him, and the people were seen flying out in all directions, some with children in their arms. Mr Hassell, a Magistrate, who resides near, has very properly interfered, and Mr Rochester has promised that on no account will he incur the same risk with any of the animals in future [!]

The Death of a Royal Marine

Leaving West Coker along the A30 road to Crewkerne, you suddenly come upon the Church of St Mary the Virgin in East Chinnock, overlooking a patchwork of fields rolling away to the south and the Dorset Hills. High on the west wall of the church, a memorial tablet bears the following inscription:

Sacred to the Memory of
Captain T.S. Denty who was drowned at Peterhead,
March 6th 1881 aged 26 years
Son of the late T.D. Denty, who was killed at Yeovil
whilst drilling the Rifle Volunteers
Death comes at unexpected times,
and unexpected hours, tomorrow we may never see
today alone is ours.

What an intriguing statement: 'who was killed at Yeovil whilst drilling the Rifle Volunteers.' No doubt many serving and former members of Her Majesty's Armed Forces, having suffered drill instruction, might conclude that the Rifle Volunteers had finally had enough drilling and assassinated their drill instructor! The facts, however, do not bear out this fantasy, although the cause of T. D. Denty's demise is not without irony.

Thomas Draper was, in fact, a sergeant of the Royal Marines, a widower with three children, and a veteran of eighteen years' service; he was also the local recruiting sergeant for the Royal Marines.

The Yeovil Rifle Volunteers were founded in 1859 and were part-time soldiers. Although these weekend warriors were keen, the Volunteers were also very much a men's social club, and two of the highlights of the year were the shooting events held on the rifle range at Yeovil Marsh during October. The 1862 contest took place on Thursday 9 October, and again on the following Tuesday, the 14th, when the Corps were accompanied by Sergeant Denty who had volunteered to help the target markers in the butts. As an experienced Royal Marine, Thomas Denty's presence would be welcomed by the Volunteers.

Following a full morning's firing, members of the Volunteers were enjoying refreshments, having just finished competing for the Ladies' Cup. The day's programme would continue after the meal by firing on the short 300-yard range, and work was beginning on patching and rearranging targets. The Volunteers did not possess two targets capable of being used separately on the long and short ranges and it was necessary, therefore, to dismantle and take one of the large four hundredweight (50.8kg) targets from the long range and fix it at the 300-yard butt.

Sergeant Denty and Volunteer William Grimes were busy patching and repainting the large targets, but apart from the arrival of Volunteer Hurlston, there was no sign of the working party detailed to move the heavy target to the short range. The afternoon programme would soon be starting but as time was running short,

The Church of St Mary the Virgin, East Chinnock.

the sergeant decided to begin the dismantling of the target on his own, no doubt muttering at the inefficiency of the 'civilian soldiers'. In trying to release one of the securing bolts, Sergeant Denty's foot slipped on the wet grass of the butt, and four hundredweight of target came crashing down on the unfortunate marine, breaking one of his legs.

In great pain, the sergeant was conveyed in a spring waggon on the bumpy road back to Yeovil and to his lodgings in the Butcher's Arms, where he was seen by Mr Fancourt Tomkyns, the honorary surgeon of the Rifle Volunteers, and his colleague Dr Aldridge. By now the patient was complaining of severe abdominal pain and despite the close attention of the two medical men, he died at 5.30 p.m. the same day. The autopsy revealed that in addition to a badly fractured leg, the sergeant had suffered a severely damaged right kidney, which had haemorrhaged into the abdomen and was the cause of death. Ironically, Thomas Denty had enlisted in the Royal Marines on the day after Sherborne Fair and died on the same day eighteen years later.

The inquest was held on the following day in the Three Choughs Hotel, where the deputy coroner Mr Craddock, having heard the evidence of the witnesses, stated that in his opinion the death of Sergeant Denty was through no one's fault. He ought not to have tried to remove the target on his own, and was 'no doubt too adventuresome'. The jury returned a verdict of 'accidental death'. Following the inquest, the £3 fees of the jury and the fees of the medical attendants were handed to the sergeant's orphaned children.

On the afternoon on Thursday 16 October 1862, Sergeant Thomas Draper Denty was laid to rest in the Yeovil Cemetery with full military honours. During the twelve months the sergeant had been stationed in Yeovil, he had become a very popular figure, and the *Western Flying Post* reported that some 3,000 people attended at the cemetery. Three volleys were fired over the grave by eighteen Volunteers under the command of

Colour Sergeant Chaffin and Corporal Denmead, and were said to have been carried out with such precision that persons at a distance could hardly believe that eighteen rifles were discharged so simultaneously. Unfortunately, the popularity of the sergeant did not extend to providing a headstone, and he lies in an unmarked grave.

And what of his son, Captain T. S. Denty? He was the skipper of the Bridport brig *Why Not*, which was sailing in ballast to Peterhead in Scotland when she was driven onto the Skerry Rocks and lost with all hands in a severe gale on 6 March 1881. The crew of seven were all local men: Captain Denty came from East Chinnock, the Mate from Burton Bradstock on the Dorset coast, and the rest of the crew were from nearby Bridport. It was reported that the brig was an 'old one and had been for many years in the Bridport trade'.

Air Raids and a Mystery

By the autumn of 1944, the rapid advance of the Allied armies to the borders of Nazi Germany had removed the threat of air raids over the West Country. The last of the 368 air-raid warnings, which had sounded over south Somerset since the summer of 1940, was given in June 1944. Four months later on 27 October, the *Western Gazette* recalled the area's air-raid experiences:

It can now be disclosed that during four years of war bombs were dropped on 106 days somewhere in the area covered by No. 8 Area, Somerset A.R.P., which embraces Yeovil Borough, Yeovil Rural, Chard Borough and Rural, Ilminster and Crewkerne, Langport Rural and Wincanton areas.

The period of the greatest strain on the thousands of A.R.P. personnel in the area was in 1940 and 1941 when there were frequent sirens by day and night, with night after night wardens and other workers 'standing by' for eight and nine hours at a time. The longest alert was 13 hours on January 4th-5th 1941. The first alert was sounded on 5 July 1940. Altogether there were 368 alerts. In the whole area 585 high explosive bombs and several thousand incendiaries were dropped, but casualties and damage were relatively small.

Yeovil Borough, against which there was enemy action on ten occasions, suffered most heavily. A hundred and seven high explosive bombs were dropped, 45 civilians were killed or died of their injuries and 115 were injured [this was later corrected to 122]. Sixty eight houses were totally destroyed, and 2,377 damaged but repairable.

In Yeovil Rural area 160 high explosive bombs and about 350 incendiaries were dropped, killing one person and damaging 419 houses.

Other places in the area where there was considerable damage were, Templecombe, Somerton, Chard Junction, Castle Cary Junction and Wincanton. In rural districts there was isolated damage to houses and other properties.

There was a sharp attack on Templecombe on on 5th September 1942 when four high explosive bombs fell on the railway station and houses in the vicinity. Thirteen people were killed and 17 injured.

Two aircraft carried out an attack at Ansford, Castle Cary, two days previously when two people were killed and two injured and railway property and houses damaged.

Two milk factories were hit in the area. At Somerton, on 29th September 1942 considerable damage was done by a direct hit and nine people were were killed and 14 injured. At Chard Junction, the factory was damaged and one person was killed and five injured.

A plane dropped bombs on Wincanton on May 15th this year. Two fell on open ground and did no damage, but another got a direct hit on a solicitor's office and the Bank adjoining in the centre of the town, doing considerable damage, and killing one person and inflicting minor injuries on a few others.

Although the foregoing were what may be described as the principal 'incidents' bombs fell on many occasions on the area without causing loss of life or damage to any great extent.

In the Wincanton rural area 152 high explosives, about 1,100 incendiaries and two parachute mines were dropped, killing 16 people and injuring 32. The houses were destroyed and 495 buildings were damaged. In Langport area 58 high explosive, one oil, 1,800 incendiary bombs and four parachute mines were dropped, killing nine, injuring 79, destroying three buildings and damaging 203. In Chard Borough, Chard Rural, Crewkerne and Ilminster areas, 102 high explosive and 350 incendiaries were dropped, killing one and injuring 13, destroying

In the whole area of about 400 square miles, 585 high explosives, 24 oil bombs, between 3,000 and 4,000 incendiaries were dropped. The killed numbered 71 and the injured 239. Eighty-three buildings were destroyed and 3,493 damaged.

However, there remains a mystery from the time. The direct hit on an air-raid shelter in the garden of No. 103 Preston Grove during the second German air raid on Yeovil on the evening of 8 October 1940 killed eleven people. Eight of the victims were identified but the remains of three were so badly mutilated that this was not possible for them.

One body identified as female was found in the allotments next to the nearby Westland airfield on 13 October. A male child's body was found on 9 October in the garden of No. 42 Preston Grove. The third unidentifiable body was found on 9 October some 100 metres away in the cul-de-sac of nearby St Andrew's Road. Despite extensive enquiries, the identities could not be established and the bodies were interred in Yeovil Cemetery Division A – Graves 3393, 4180 and 4186.

At the time of the air raid there were many hundreds of evacuees in Yeovil, many official but many not so. The evacuees came from London and other large cities and it is possible that the three victims were unofficial evacuees. As it is unlikely their identities will ever be known, the mystery will remain.

The headstone marking the graves of the three unknown air raid victims in Yeovil Cemetery.

Church Stories

Kilmersdon

From the *Western Gazette*, 9 January 1874:

A most amusing affair occurred at Kilmersdon Church on Sunday. While the congregation were deep in their attention to the eloquent sermon at the evening service, some wag, who discovered the key to have been left in the outside of the church door, conceived the idea of imprisoning the whole congregation, and forthwith parson, clerk, and the parishioners were locked in. Even the worthy sergeant of the local constabulary, who has turned the key upon so many in his time, had the key turned upon himself by way of a change. Great was the consternation of those within and the amusement of those without. There was no help for it but to wait until the lock could be taken off, and this having been at length accomplished, 'the prisoners were discharged with a caution,' – not to leave the keys outside the door on a future occasion. It is to be hoped that Mr. Whitting will make 'a case' out of this little affair, for the rascal who dared to lock up a police sergeant at his devotions certainly ought to be punished.

Chew Magna

From the *Western Flying Post*, 19 June 1866:

A great deal of unpleasantness has been occasioned through the ringers at the church not being permitted to give forth merry peals when parties are married, if the ceremony did not happen to be performed at the church. On 9th April they were given to understand that if they would ring, in order to celebrate the confirmation service, they might have license to ring whenever they pleased; but on Sunday last they were debarred from celebrating the marriage of a couple who chose to wed out of the parish, and when they presented themselves at the belfry door it was locked. The bridegroom, however, rewarded them, taking the will for the deed.

Long Sutton

Before entering the parish church of Holy Trinity, Long Sutton, by the north door, visitors should glance up at the battlements over the door where a large uncut piece of stone stands. Legend says that this was the Devil who, driven out of the church by the preaching of the gospel, took his stand over the porch to try and prevent people from entering to worship. A good story but the question remains: why was a lump of stone placed on the battlements – when and by whom?

KILMERSDON CHURCH *Will best love, from your loving Amy*

Kilmersdon Church where the Sunday evening congregation were locked in, January 1874.

Norton-sub-Hamdon

In January 1870 the old sexton of the parish church of St Mary the Virgin, Norton-sub-Hamdonhad, had been ill for some time and a stand-in had been appointed to carry out his duties. However, at a burial carried out in the first week of January, someone else was employed to dig the grave. The regular stand-in took exception to the competition and when the two men met in the church tower before the Sunday morning service, a row broke out. The stand-in knocked the interloper down, seized him by the throat, and then banged his head against the wall of the tower. The report of the incident in the local newspaper declined to name the parties, but it was felt that the stand-in's actions could be prejudicial to his chances of further employment in the churchyard!

Odcombe

Malicious and pointless damage is not a phenomenon confined to our present time, but was alive and well in good Queen Victoria's days.

In 1866 the villagers of Odcombe were horrified to learn that during the night of 17/18 February someone had broken into the parish church, picked the lock of the harmonium, and cut the strings of the treadle attached to the bellows. This was the second time the harmonium had been vandalised. On the first occasion the strings had been partially cut through and broke when the instrument was played at the subsequent service.

The *Western Flying Post* thundered that it trusted 'The dastardly fellow who committed this outrage will be discovered and punished. Such an act is a disgrace to

the parish.' Was the perpetrator someone who didn't appreciate harmonium music? Whoever it was, was never caught.

Merriott

The thought of being buried prematurely is a truly awful prospect, and to many of our Victorian forebears it was a morbid dread. Much of the literature of the time, especially the Gothic horror stories from the pen of Edgar Allan Poe (1809–49), only served to re-enforce this dread and send shivers down the spine of the reader in the flickering lamplight by rattling windows on a dark and stormy night.

Readers of the *Western Gazette and Flying Post* on 4 March 1870 might have felt such shivers down their spines at the following account of an 'occurrence' in the churchyard of All Saints, Merriott:

> Merriott
> Buried Alive
>
> A rumour has been circulated that Richard Parsons, whose death we recorded last week, was buried alive on Monday last. The sexton states that as he was filling the grave he heard a groan, as if proceeding from the coffin. He did not, however, take any notice of it but filled the in the grave. Deceased had been ill for three months and died as was supposed on the 17th. He was placed in his coffin, the lid of which was screwed down about four hours before the burial. The matter is to be investigated by the Parish authorities.

However, nerves were probably calmed the following week when the newspaper stated that it had been asked by Mr Charles Parsons of Somerton to write that the supposed burial in Merriott was 'partly untrue and partly founded on village gossip'.

Bristol

From the *Taunton Courier*, 31 January 1827:

> On Saturday last a grave was ordered to be made in St. Paul's burial ground in Bristol, of 10 feet deep and width accordingly, and to be finished by ten o'clock in the morning. Fortunately, the undertaker was punctual to the time for the arrival of the corpse for interment the grave was found to be nearly filled up, and groans were heard coming from underneath. Assistance was immediately procured and after digging some depth a hat and wig came up, and soon after the grave digger himself made his appearance; he was taken out in a very exhausted state, and carried home.

A Death by Fighting

History is silent on the reasons for the quarrel between two young men in April 1839, but it was sufficient to result in the death of one of them some three weeks later. And so nineteen-year-old Edmund Cullener and Henry Coward (twenty) decided to settle their differences with a bare-knuckle 'prize fight' for a sovereign to the winner on the morning of Monday 14 May.

At around 9 a.m. that day, the two men, accompanied by their seconds and water bottle holders, met in a field on the Wiltshire side of the Dundas Aqueduct, which carries the Kennet & Avon Canal over the River Avon, some 4 miles from the city of Bath. The news of the fight had drawn a large crowd hoping for good sport and a chance to earn some cash by betting on the outcome.

The fight began just after 9 a.m. Two and a half hours and 135 cruel rounds later, and both men were still trading blows but so weak and exhausted that they were being dragged back to fight by their seconds and thrown against each other until Edmund Cullender, after muttering incoherently, collapsed unconscious. The sport over, the field emptied, with cash jiggling in the pockets of the wager winners. Edmund Cullener was carried back over the Dundas Aqueduct to the nearby Brass Knocker Inn. Still unconscious, he was placed in fly carriage and driven to his lodgings in St James' Court, Lower Borough Walls, Bath.

Edmund Cullender's condition began to deteriorate and a surgeon, Mr J. Barrett, was called, but despite his efforts Edmund died at 7 p.m. that day, without having regained consciousness.

The next day, Tuesday 15 May, coroner A. H. English Esq. opened his inquest on the deceased in the Lamb Inn when Edmund's brother told the jury that the quarrel had arisen some three weeks before and his brother had resolved to fight his opponent, 'declaring that he would rather than give up, if he could not beat him, he would die on the ground'.

Mr Parker of the Aqueduct Hotel testified that when he had been told of the fight he had gone to the field with the intention of stopping it. However, he stated that on his arrival 'The means which he possessed were quite inefficient for the purpose, there being a large congregation of the lowest blackguards assembled to witness the affair, who, he believed, if he had proceeded to use any force to stop the battle, would have fallen upon him'. Mr Parker went on to say that the 'only apparently respectable person he saw was Mr C Rudge of the Black Swan in Broad-street, Bath'.

A number of witnesses testified that Mr Rudge was the timekeeper, John Backcoller was the deceased's second and Henry Coward was John Hicks's. The witnesses also told that when the fight was over, the seconds, the unnamed water bottle holders and the stake holder left in a hurry, leaving the two fighters to 'die on the ground or get away as best they could'.

The coroner issued a warrant for Mr Charles Rudge to be brought immediately to the inquest, and on his appearance he made a voluntary statement. Rudge deposed that he had gone to the Brass Knocker Inn with two friends but had just ordered some ginger beer when he heard that there was to be a fight in a field around half a mile

54313. View across the Viaduct from Combe Down, Nr. Freshford, Bath.

This peaceful scene was where a vicious bare-knuckle 'Prize Fight' took place in May 1839.

away, and with his friends and other customers he had gone to watch. He admitted that he might have occasionally taken out his watch to see the time, but he was not the timekeeper. Indeed, when on three occasions he thought the weaker of the two fighters had not been given sufficient time to recover, he had tried unsuccessfully to stop the contest. The witness explained that he had succeeded in stopping the fight on the fourth occasion of trying.

Charles Rudge called one of his friends by name of Moore to confirm his statement, but despite saying that he had seen Rudge pull out his watch on several occasions when asked the time, he could not tell who had asked him or whether his replies had stated the time of day or the time of the rounds.

Surgeon Barrett testified that he had been called to the deceased's lodgings at 2 p.m. on the Monday and found the patient insensible and suffering from severe bruising on the chest, to the front of the head and the face, and his right arm and hand were very swollen. Mr Barrett stated that he had carried out the post-mortem and had found extensive bruising of the scrotum, both lungs gorged with dark blood and there was considerable bleeding on the brain. He was of the opinion that the injuries suffered by Edmund Cullender were the cause of his death.

Following the surgeon's evidence, the jury were sent out to consider their verdict and, following half an hour's deliberation, returned a verdict of manslaughter against Henry Coward as the principal and against Charles Rudge, John Blackcaller and Joseph Hicks as stake holder and seconds. The four were committed for trial but Coward was too ill from the effects of the fight; a policeman was set to guard him until he was fit enough to be transferred to the County Gaol at Taunton.

On 13 August Henry Coward appeared before Mr Justice Coleridge at the Somerset Assizes in Bridgwater, charged with the manslaughter of Edmund Cullener near Bath

on 14 May, together with Charles Rudge and Joseph Hicks, who were charged with 'having aided and abetted him in the commission of the felony'. No reason appears in the record to explain John Blackcaller's absence.

The prosecution set out the case presented at the inquest and the witnesses were called and repeated their evidence. Then came the defence, with Mr Edwards leading for Henry Coward, who addressed the jury by admitting that 'a verdict must pass' against his client but asked for the mitigation of punishment.

Mr Stone for Charles Rudge contended that his client had been present by accident and had done everything that a man could do to prevent the fight from continuing. Indeed, Charles Rudge had even offered to pay both men a sovereign each if they would stop. Counsel was most confident that the jury would acquit his client.

Addressing the jury on behalf of Joseph Hicks, Mr Merewether conceded that a verdict of guilty would be returned against his client but asked for the punishment to be mitigated. The learned counsel proceeded to suggest that this mode of settling a quarrel was part of the national character and when the calendar of cases for trial teemed with malicious cuttings and stabbings, this was not the time 'to visit with a severe punishment those who used the weapons with which nature had furnished them, in a fair fight, the means of settling a quarrel'.

Several witnesses were called who gave Coward and Rudge 'good characters for humanity'. In summing up, Mr Justice Coleridge observed that:

> Those who went to fight and by their presence encouraged it, and stood looking on without endeavouring to prevent it, were guilty of aiding and abetting those who were engaged in the contest, and therefore it was requisite to state, though it might be unpalatable to some who heard him, that persons who so acted, if death ensued, were guilty of manslaughter. This was a prize fight, and, was distinguishable from those chance encounters which took place between parties, who, upon a quarrel, had immediate recourse to those weapons which nature had given them. Prize fights were attended with riot, drunkenness, betting, and gambling, and very often ended in the death of one of the parties. They were unlawful in the sight of God and man, and must be put down by the strong arm of the law.

The jury were then sent to consider their verdict and following a long deliberation found all three guilty as charged, with a recommendation of mercy for Henry Coward and Charles Rudge.

Mr Justice Coleridge then passed sentence and in doing so stated that he believed Rudge had arrived at the Brass Knocker Inn without knowing about the fight, but had then gone and called the time. However, although he had become fearful of the outcome and had tried to stop the encounter, punishment must be awarded accordingly to all the circumstances of the case. He then sentenced Henry Coward and Charles Rudge each to one year in prison, and Joseph Hicks, to thirteen months – all with hard labour.

A Mayor's Shocking Death

Councillor Norman Buchanan was a popular and prominent townsman. Born on the Isle of Lewis in December 1857, he was a successful draper and outfitter, a business he had developed since arriving in Yeovil in 1880.

Mr Norman Buchanan was elected to the Yeovil Borough Council in 1906, was unanimously elected mayor in November 1912 and was serving his fourth term of office on New Year's Eve 1915.

During the months following the outbreak of war on 4 August 1914, in addition to his extensive and onerous mayoral duties, Councillor Buchanan was heavily involved in the organization of relief and recruiting committees, and had been untiring in his efforts on behalf of the Belgian refugees; it was said that 'no duty was too great or any detail too small' for the mayor's attention.

During the evening of 31 December 1915, the mayor attended an army recruitment meeting in Crewkerne in company with a good friend, Mr Fred Weston. On their return to Yeovil just before 11 p.m., the mayor dropped his friend off in Crofton Park and, calling out 'Goodnight Fred and a happy New Year to you. I'll see you in the morning', drove off in his motor car to his home at Osborne House, Sherborne Road.

Councillor Norman Buchanan was a popular mayor and a prominent Freemason member of the Yeovil Lodge of Brotherly Love No. 309.

Arriving home at just after 11 p.m., Elsie Flooks, the housekeeper, told the mayor that his wife Rose had gone to bed as she was tired, and after wishing Elsie a happy New Year started to run up the stairs to bed. At the fifth stair, his foot slipped on the smooth velvet pile carpet and he fell backwards down the stairs, crashing into furniture and striking his head on the stone flags of the hall. Alarmed by the sound of the fall, the housekeeper ran into the hall and Rose rushing down the stairs found her husband lying unconscious on his back bleeding heavily from a severe head wound, and the family doctor was soon in attendance.

After regaining consciousness, the mayor appeared to recover and began to improve, but on 13 January he lapsed into a coma and died four days later. The author's mother, a cousin of Rose Buchanan, could remember that straw was laid on Sherborne Road outside Osborne House to deaden the rattle of the iron cart and carriage wheels on the road surface so as not to disturb the sick man.

The cause of death was 'concussion of the brain' and at the inquest the jury heard evidence from Mr Fred Weston and Elsie Flooks and the statement from Mrs Rose Buchanan that during a period of consciousness her husband had told her that he had been wearing resoled shoes and he believed this had caused him to slip on the smooth pile of the velvet stair carpet. A verdict was returned that death arose from the concussion of the brain following a blow on the head caused by an accidental fall downstairs.

The funeral was held on Saturday 22 January, and the *Western Gazette* reported, 'Rarely has the Borough witnessed such a scene of mourning, for the inhabitants turned out en masse to pay a last tribute of respect to a devoted public servant.' Shops were closed and shuttered, many displaying flags at half-mast, and the streets were lined with townsfolk as the funeral procession passed up Middle Street to the Borough, through High Street and along Princes Street to St John's Church. Following the funeral service, the procession made its way to the cemetery where a large crowd had gathered by the graveside to pay their last respects.

The *Western Gazette* wrote on 26 January 1916: 'And so passed Mr. Norman Buchanan, four times Mayor of the Borough of Yeovil and whose many activities, as has been aptly said, ended with the old year, and whose memory will ever be green in the annals of local government in such momentous times in the history of the country.'

Drunk in Charge of a Steamroller

There was a change from the usual procession of trespassers, drunks and other petty crimes to regale the county magistrates at their session in Yeovil on 5 June 1895. John Barber, described as an 'engine driver', was charged with being drunk in charge of a steamroller at Ilchester on the 3 April previous, and bearing in mind the size and weight of such a machine, it could cause some mayhem if let loose in a built-up area.

The first prosecution witness was Richard Dennis (a baker), who told the court that on the day in question he saw the defendant repeatedly enter and leave the Bull Hotel at Ilchester, and when he left the village driving the steamroller at around 5 p.m., he appeared to be under the influence of drink. Around an hour and a half later, the witness testified that he saw the steamroller on the Martock road with one wheel in the ditch and the driver John Barber 'in a very excited state'.

Police Sergeant Richards corroborated this evidence, and stated that he had received a complaint about the defendant's conduct.

Mr J. Trevor-Davies, the solicitor representing John Barber, interjected and stated that the police witness should not be permitted to make such a statement as it cast an imputation on his client. However, the chairman of the bench held that the witness had not exceeded his right and told him to continue. Sergeant Richards stated that he had said to the defendant: 'You must be drunk or you wouldn't have the engine in

The Bull Hotel in Ilchester where John Barber had been drinking before he was accused of being drunk in charge of a steamroller.

the ditch!' Barber was very drunk but not excited. The steam had not been shut down and there was an extraordinary pressure of steam in the engine.

Opening in his client's defence, Mr Trevor-Davies commented on the absurdity of the sergeant's evidence alleging that because his client had met with an accident he must have been drunk. There was also an inconsistency in the evidence given by the two witnesses on the condition of his client, who, incidentally, had been in charge of machines of this kind for many years without a single complaint against him.

The first witness for the defence was road contractor George Eddicott, who testified that he employed John Barber and on the day in question had given him his orders at the Bull Hotel. He had been sober both then and when the witness saw him again at the site of the accident.

The next to give evidence was Thomas Thomas, who stated that he had been in charge of the bar at the Bull Hotel and had only served the defendant with two cups of ale, which he had then drunk with a friend. He hoped that the bench would be lenient for 'a more civiler man he never knew'. Road labourer Isaac Griffin corroborated Thomas Thomas' testimony.

At this point, the magistrates decided that they did not wish to hear any further evidence and dismissed the case.

Strange but True

From the *Wells Journal* of 10 February 1855:

Superstition in Langport
Some time ago a man of this town was afflicted with fits, which the doctors were unable to cure. After trying various means, he applied to a *wise man*, who lives in this neighbourhood, and was informed that he was overlooked or bewitched, but that he (the conjuror) was in possession of a secret which would entirely remove the effects of the bewitchment, and the party which bewitched him would be overlooked. Accordingly, a Sunday night was appointed, when the wise man was to visit Langport and perform the enchantment, for which he was to receive one sovereign. The night came: but in the meantime the dupe had made up his mind that his landlord's wife had overlooked him, and the conjuror on coming was informed who the party was. The incantations began with a game of cards, after which several bottles of stuff, containing a quantity of pins were burned in the fire; then the 37th Psalm was read three times backwards, and another bottle of stuff was produced, containing a heart stuck full on pins, and tightly corked, the cork also full of pins. Some incantation was then performed, and a prayer used by the conjuror, upon which the bottle was buried underneath a part of the floor, he, the said cunning man, declaring that so long as it remained there the overlooking party would be subject to disease, and the magic farce concluded. The landlord's wife, a few days after this event, was taken ill, and, it is said, complained of pricking pins; defying all the skills of the doctors, who disagreed about the nature of the disease. Some few weeks ago, a person of the town speaking of the bewitchment, and of his being present at the incantations, the husband of the woman went with him, when he related the whole of the above. The magic bottle was then dug up, and, it is strange to add, the woman is getting better.

From the *Frome Times* of 31 May 1865:

Witchcraft
A regular disturbance took place in South Street, Taunton, a few nights ago, consequent on a belief on the part of a man named Glide that his neighbour had bewitched his horse, the animal not having been able to do so much work as before. He consulted a 'cunning man', who lives near, and professes to tell fortunes, and he told him that a woman with dark hair was the offender. He at once pitches upon a near neighbour, and a fearful row was the result which was only put to an end by the interference of the police.

From *Pulman's Weekly News* of 3 December 1865:

A Gross Superstition
In a hamlet not a hundred miles distant from the county town of Taunton a circumstance has occurred which has given rise to a considerable comment and

much pity for the credulous dupe who walks in the respectable ranks of society. A farmer lost a valuable cow, not from the dreaded cattle plague, but the animal expired shortly after calving. From this and other losses the farmer sustained, the farmer verily believed that an 'evil eye' was upon his house, and that the unholy practices of a witch had led to his misfortunes. After grave consultation with his better half it was decided that a 'wise man' should be consulted, and if not a 'wise man' certainly a 'cunning man' who resides in the neighbourhood. He was consulted, and in turn consulted his works on astrology, and having 'read the stars' he was firmly of the opinion that a veritable witch presided over the destinies of the farm. He had an eye for business, too, and knowing that his patron was well to do, he could not counteract the effect of the 'evil one' without five sovereigns of the latest dates that could be procured, were handed over to him. This being done, he ordered the farmer, his wife and family, and the labourers on the farm to meet him at the witching hour of night to see the carcase of the defunct cow burnt. They assembled in a field, when the 'cunning man' told them that if either present spoke one word during the process of burning, the spell would be broken, but if they maintained perfect silence the 'witch' would be attracted to the spot, would be unable to move, and then blood could be drawn from her arm, and the misfortunes of the farmer would cease. A huge fire was lighted and when a hundred and a half of good faggot wood had been consumed, one of the labourers exclaimed 'Drat the cow, that wood was to thatch my rick, and the beast won't burn.' The 'spell' of course was broken, and the 'cunning man' ceased his incantations, declaring that he saw in the distance the 'witch' approaching, but that she vanished upon hearing the luckless words of the labourer who was then and there soundly rated for his stupidity. With doleful looks the party ceased their midnight vigil, and the disappointed, but credulous farmer, is looking out for the next catastrophe.

A girl was supposed to have been bewitched at Castle Cary in 1866.

From the *Western Gazette* of 29 June 1866:

A Superstition in Castle Cary
A girl here is popularly supposed to have been bewitched. For some weeks she has occasionally suffered from what appears to be fits, but it is mentioned as a somewhat suspicious circumstance that she appears to have 'fit' at any moment she pleases. During these attacks she has named several persons who she says have bewitched her, and refers to one in particular as having appeared to her and tempted her to drown herself. Her friends have raised a subscription and spent the proceeds in a journey to Somerton to consult a 'witch' residing there. The verdict of this 'witch' was that the girl was *not* bewitched but that somebody had 'wished her a bad wish'. And this valuable information was all the poor foolish people got for their money; and yet we are apt to talk as if all the heathen lived in different countries.

And finally, the strange and haunting 'Meet me by Moonlight' from the pen of a long-forgotten surgeon, writer of lyrics, composer and conductor, Dublin-born Joseph Augustine Wade (*c.* 1796–1845).

> Meet me by moonlight alone,
> and I will tell you a tale.
> Must be told by the moonlight alone.
> In the grove by the end of the vale.
>
> You must promise to come for I said
> I would show the night flowers their Queen:
> Nay, turn not away thy sweet head,
> 'Tis the loveliest ever was seen.
> Meet me by moonlight alone.

A Boxing Match, 1911

'Professor' Tim Sullivan's posters announced his promotion of a ten-round boxing contest at the Fairfield in Huish on 12 July 1911. It was for a purse of £20 and was between Tom Rogers, the 'local 10 stone champion', and Jim Frain of Nottingham and later of Yeovil, 'the 10 stone champion of Nottingham'. Posters appeared across the town and immediately a row broke out.

The *Western Gazette* reported:

The contest was the principal subject discussed at the various Men's Adult Schools on Sunday morning, at which there were large audiences. In the course of his address to members of the Parent School, Mr A S Martin referred in strong terms to the introduction of 'such a degrading exhibition as a prize fight' into the town, and, after a prolonged discussion, a condemnatory resolution was proposed by Mr C Windsor, and carried unanimously. Similar resolutions were passed by the Pen Mill and Huish Adult Schools.

At the South Street Baptist Church on Sunday morning the Pastor (the Rev. W G Butt) also made reference to the subject, and said that all Christian people ought to raise their voices in protest against it. At a united gathering of the Weslyan United Bible Classes a resolution was carried protesting against 'the introduction into our town of such a degrading exhibition as a prize boxing contest, and asking respectfully that the Mayor and Council will prevent the same.' It was unanimously decided to send the resolution to the Mayor, Town Clerk and Police Authorities. Other letters have been drawn up and forwarded to these quarters.

It should be stated that that the man styling himself to be 'Professor Tim Sullivan', a stranger to the town, has erected the pavilion where the contest is to be held. The field is the property of Yeovil Corporation and it is freely rumoured that they will request the police, in view of the protests to stop the contest from taking place.

In spite of the protest, the town council did not withdraw permission, the police were not asked to intervene and the large crowd that assembled at the Fairfield on 12 July in anticipation of the arrival of the authorities, went home disappointed. Some stayed, however, and paid for admission to the pavilion, including several members of the town's churches and chapels who had come to 'witness the fight'.

Just before the proceedings commenced 'Professor' Sullivan surprised the audience by announcing that as the 'gate' was smaller than anticipated, he could not afford the original purse of £20, and suggested that the men should either fight for £5, later increased to £5 10s by a member of the audience, or take half the admission proceeds. After consideration, Rogers and Frain agreed, to cheers from the audience, to fight for the money, with the winner taking £3 10s and the loser £2.

Members of the Yeovil Pen Mill Adult School, off Cromwell Road, voted unanimously to condemn the proposed Prize Fight on 12 July 1912.

The *Western Gazette* wrote:

Sullivan then referred to the attacks that had been made on the contest and the futile attempts to stop it. He wanted everyone present to understand that it would have to be fought fairly, and any person passing a remark whilst the men were fighting would be removed. He wanted to prove to the people who had protested that the sport could be carried through as respectably as any other, a remark which was greeted with further applause.

The contest then commenced under the Marquis of Queensbury Rules, but in the fourth round Rogers fouled Frain and the referee declared Frain the winner. The *Gazette* reported that 'neither contestant was injured in the slightest degree' – was all above board in this show?

The Foul River Yeo

In 1875 sanitary districts were established for the towns and country areas and made responsible for various matters of public health, such as providing clean drinking water, sewers and sewage disposal. In the towns, town councils were the responsible authority and in the countryside these duties were placed in the hands of the Poor Law Unions.

In Yeovil, the town council was the sanitary authority. In the countryside around the town, the responsibility was with the Yeovil Board of Poor Law Guardians, who managed the workhouse on Preston Road.

During the summer and early autumn of 1887, the Yeovil Board received a number of complaints about the shocking condition of the River Yeo and instructed Dr J Adams, the Board's Medical Officer of Health to investigate and report. In company with Mr George Langdon, the Board's Rural Sanitary Inspector, the doctor surveyed the length of the river from the town to Yeovil Bridge. This is his report:

> I have inspected the River Yeo from the point where the sewage of Yeovil is discharged into it, and from there down so far as Yeovil Bridge. The sewage from the Town of Yeovil enters the river at the outlet from the main sewer about 300 yards distant from the town railway station. The 'Town Mill' stream also carries sewage, and being a tributary to the river adds to the pollution. The River Yeo below the outlet is very foul; the water appears black and smells offensively; for some distance above the sewer outlet the pollution of the river is very evident. At the time of my inspection, the water was low, and the river bank high and low water mark was completely covered with black slime. Immediately above Pen Mill the river was covered with a mass of stagnant solid sewage matter; there was a very foul smell arising from the mill pond. At Yeovil Bridge the pollution of the river with sewage was very evident from the smell and colour of the water. I am informed that large quantities of fish have died. I consider that the condition of the river is prejudicial to the health of persons living within range of its emanations, notably at Pen Mill and the houses at Yeovil Bridge. Whether the town is itself effected thereby, I am unable to determine, but I am of opinion that such a mass of liquid sewage is always a probable source of danger.

Mr George Langdon appended his report to that of Dr Adams', which reads as follows:

> In accordance with your orders of September 30th, respecting the town sewage of Yeovil polluting the stream, I inspected the stream and found the town sewer discharges into it about 300 years from the station, near the weir. I found the bed of the stream near the outfall in a very bad state of sewage. I followed the stream for about a mile and a half across the fields, and found it very badly polluted. A various points where the stream winds the water was very dark with sewage. The scum at these points was very thick with sewage matter and of an oily greasy nature. The whole stream seemed to be in a very unwholesome condition.

A much cleaner river in the 1930s.

The board sent the reports to the town council, who replied that as sewage from the Union's area entered the streams that then flowed into the River Yeo, they were contributing to the nuisance.

However, in December, the Sherborne Union sent a letter to the town council requesting the pollution be stopped and, if not, fourteen days' notice would be served requiring the nuisance to be abated. Once again, the town council considered that attack is the better form of defence. They replied that the pollution was no worse than it had been for thirty-five years and, as the Sherborne Union's area adjoined the river, if there was any nuisance, they contributed to it. If, therefore, the Sherborne Union took any action against the town council, they would apply for an order against them.

It seems that the town council's reaction to the problems of sewage and pollution was to 'leave well enough alone' or as one Alderman stated 'We shall only deal with sewage when it is forced on us. We have done enough for our time!' However, the inevitable could not be put off forever, and sixteen years later in 1903 the new sewage works was brought into operation at Pen Mill, where it still remains. Today the River Yeo is clean, and a pleasure to fish and to walk beside.

Surprising Weather

1883: A Whirlwind

At noon on Saturday 17 November 1883, the sky went black, rain cascaded in torrents and a whirlwind came out of the west. Touching down on Brympton, it smashed into the splendid avenue of trees leading down to Brympton d'Evercy House, felling several magnificent specimens, badly damaging a number of farm buildings and tearing the roofs from cottages in Alvington.

The whirlwind tracked towards Yeovil, scattering hayricks, felling and snapping trees. It passed across Watercombe Lane and along the present northern boundary of the Westland airfield. Roaring down what is now Beer Street and on to Horsey Lane, the wind tore through the garden of Mr Watts' Hendford House, tearing up a large old Chichester Elm.

Turning sharply south, the swirling wind crossed Horsey Lane, smashed into Messrs Bradford's corn stores and stripped the tiles from the roofs, scattered timber in all directions at the Hendford Goods Yard, blew two horses off their feet and a cattle rail truck along one the sidings – the horses were unhurt.

Crossing Hendford Hill over the railway bridge, the whirlwind went up the valley of Southwoods and across the Aldon Estate, felling young trees and stripping branches from mature specimens. A tall Ham stone chimney at Aldon House was blown down and crashed through the roof, damaging a bedroom and tiles flew off outhouses.

The whirlwind roared across the top of Ninesprings and Constitution Hill and over Summerhouse Hill, tossing aside a large farm cart on the way. Down through Newton Copse it travelled, leaving a trail of felled and damaged trees and blocking the Newton road to Stoford. A roof was blown off a barn at Newton Farm and a large elm tree was lifted out of the ground and left standing on its roots!

The whirlwind crossed the River Yeo and went on its way on to cause damage at Bradford Abbas and Sherborne, before disappearing as fast as it had appeared. Eye witnesses reported that the storm had lasted barely two minutes and thankfully, despite the widespread damage, no one was hurt.

1894: Floods

It rained all day on Saturday 10 November 1894 and continued throughout Sunday and Monday; there was a break during Tuesday morning and afternoon, but in the evening a gale blew up and it rained until midday on Wednesday. Rivers broke their banks and there was extensive flooding from Devonshire to Hampshire.

Many of the low-lying parts of Somerset were underwater, rail and road communications were in trouble, hundreds of acres along the River Yeo were flooded, roads were impassable on foot, and children in Ilchester and Mudford had to be taken in carts through the water to their schools. Yeovil Market was deserted because it had proved impossible to drive cattle and stock through the flooded roads and lanes into the town.

The railway lines at both the Yeovil Pen Mill and Town stations were under at least 2 feet of water, causing train disruptions, especially on the Great Western lines. A landslip on the line between Sherborne and Milborne Port disrupted the Waterloo–Exeter trains for a short time, but the Yeovil–Taunton line was the most badly affected with serious flooding at Langport and near Martock.

The *Western Gazette* recorded, somewhat lyrically, the scene at Yeovil Bridge:

> On Wednesday evening the scene at Yeovil Bridge, which divides Somerset from Dorset, was one which will not readily be forgotten. The water was above the highest point of the three arches which form the spans of the bridge, and rushing through them miniature rapids were formed, which carried every floating object through with irresistible force and created a roar which resembled a huge waterfall. From this point looking up the valley towards Mudford was a long stretch of water, almost resembling a turbulent sea, the course of the bed being absolutely indistinguishable. The colours of the brightly tinted clouds, as the sun was sinking below the western horizon, were reflected on the rushing and foaming water, and in the distance the cloud-lights were seen to be fantastically playing upon the surface of the flood, and giving gorgeous though but fleeting colouring to a scene which is but vary rarely witnessed. The same effect was also observed on the water covering the meadows between the bridge and Newton House.

In Somerset, the town worst affected was Langport, where all previous flood records were broken. Bow Street, Market Place and Cheapside were flooded to a depth of over 5 feet and small boats were sailed up the main street from the River Parrett.

1932: Another Flood

Shortly before noon on Saturday 9 January 1932, the wind rose and the rain lashed across Somerset. The storm raged for twenty-four hours, causing rivers and streams to break their banks and floodwater poured over the surrounding countryside.

The River Yeo broke its banks in several places. Ilchester was cut-off from Yeovil, with floodwater lying to a depth of over 3 feet on the A37 – the village could only be reached via Tintinhull. At Stoford, the road to Yeovil was under several feet of water and travellers wishing to reach Thornford could only do so by way of Yetminster or Sherborne, as the road at the foot of Clifton Maubank Hill was impassable.

Mudford was badly affected by flooding from the River Yeo, and remained so for several days. The *Western Gazette's* correspondent was on hand to report:

> Although the floods have receded somewhat, large areas are still under water as the result of the heavy rainfall during the week-end. At Mudford, many motorists have had considerable difficulty in negotiating the road over the bridge, which is flooded for some hundreds of yards. Quite a number of cars each day have been stranded, and have been compelled to await assistance to be towed out. A motorist on Wednesday came to a halt where the water was deepest. The driver of a lorry drew alongside and leapt from the vehicle on to the car, but his efforts to start the engine were unavailing. Finally several men in waders went to the rescue. This type on incident is a frequent occurrence. It will be some time before the river regains its normal level judging by the state yesterday (Thursday).

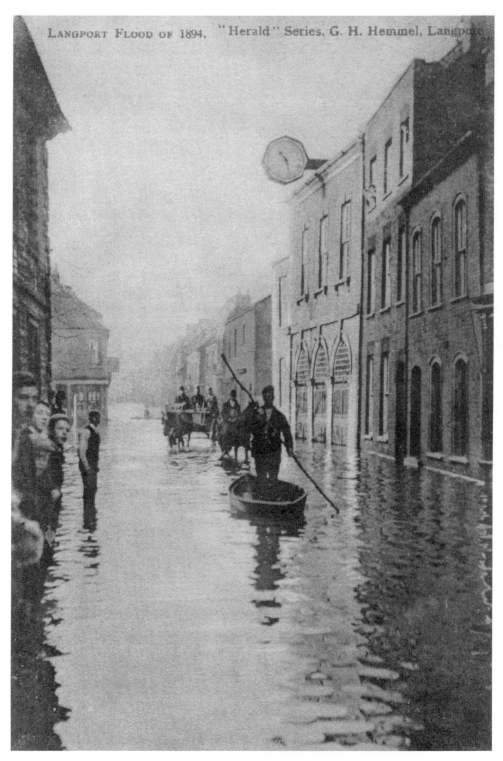

Boating though Langport during the flood of November 1894.

The heavy rain resulted in the River Parrett breaking its banks and flooded over a 1,000 acres in the Langport, Burrowbridge and Athelney areas to a depth of several feet. It was reported that the Somerset Levels resembled a huge inland sea, broken only by clumps of withies, hedges and fences. Despite the floodwaters rising perilously close to the Taunton railway line at Langport, there was little local anxiety and a resident commented laconically that: 'We have had no more flooding than usual.'

1978: Snow

On Saturday evening on 18 February 1978, a blizzard swept in and within hours there was chaos. Towns and villages were cut-off by large snowdrifts, some as high as 15 feet, and virtually everything came to a standstill. Services ground to a halt, hundreds of people were stranded in cars, coaches and trains. Remote, and sometimes not-so-remote, villages and hamlets were isolated as roads and lanes disappeared under the blanket of snow.

The *Western Gazette's* front page headline for 24 February was 'WE WERE SNOWED UNDER - Now Counties start totting-up for week-end of "WHITE HELL".'

Yeovil was completely cut-off from the outside world from late Saturday night until Monday evening, when snowploughs finally opened the A30 link with Sherborne. Snowploughs and farm tractors fitted with snowblades slowly cleared roads to the outlying areas, while on the main roads work was hampered by abandoned cars. Food supplies were soon running short in some more remote areas and emergency deliveries were made by helicopters from RNAS Yeovilton, until they were grounded by dense fog during Tuesday.

In towns and villages people were out snow clearing, and for a while a 'wartime spirit' returned as neighbour helped neighbour and no doubt in many cases had more conversations than they had had for years!

Three expectant mothers were airlifted by helicopter to Yeovil Maternity Unit, using the roundabout at Kingston as a landing pad – all three babies, two boys and a girl, were safely delivered.

A coach party returning to Yeovil from a Bristol pantomime was forced to stop at Shepton Mallet and spent four nights sleeping rough until Wednesday.

A slow thaw set in and by Tuesday all the main roads were passable with care, but because of the volume of snow, many minor roads and lanes would remain closed for several days to come.

A JCB digger had to rescue a snowblower stuck in massive drifts near Dorchester. Westland Aircraft placed two helicopters at the disposal of Yeovil Police, one of which was used to carry out a survey of the entire division. There were two helicopter trips to Sherborne to pick up frozen food from Hunts Frozen Foods for Westland Aircraft's canteen. An army lorry was used to bring desperately needed newly laundered sheets, pillow cases and linen to Yeovil Hospital from Mendip Laundry at Wells.

Napoleon's Men

In the south-east corner of the Churchyard of St Peter and St Paul, Wincanton, there is an echo of the time when the whole of Europe was ablaze with conflict and Great Britain stood alone against the might of Napoleon Buonaparte. Here stands a headstone bearing the names of two French surgeons, Pierre Jacquet and Jean Baptiste Fioupe, who died in 1806 and 1807, and includes the simple sentiment 'He was a prisoner of war but death has made him free.'

In 1805, Great Britain was at war and Europe lay at the feet of Napoleonic France, but despite the fear of invasion from across the English Channel, Britannia still ruled the waves. There was a stream of prisoners from captured enemy ships being distributed to various parts of the country, some to prisons, some to the hulks floating in ports and river estuaries and some to parole towns for officers where secure accommodation could be obtained in private houses and premises on the captives undertaking not to escape. Wincanton was established as a parole town, and in September 1805 the first batch of twenty prisoners taken in the capture of the forty-four-gun frigate *Didon* arrived; during the next seven years, the town would be host to some 500 men and boys.

The Frenchmen were dispersed throughout the town; the 1811 census shows that nineteen houses were occupied by 219 'French Prisoners of War'. The imprisonment was far from strict and the prisoners were allowed the freedom to move about Wincanton

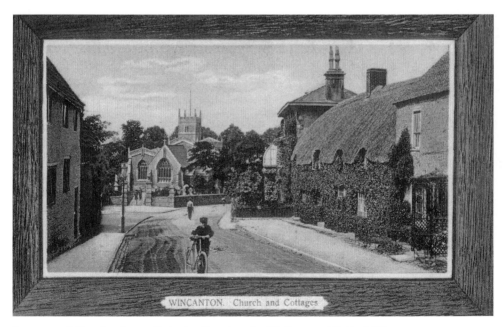

WINCANTON. Church and Cottages

Seventeen of Napoleon's men lie in the Churchyard of St Peter and St Paul, Wincanton.

and to walk for a mile outside its boundary in all directions. There were entertainments and indoor recreations, and the Frenchmen were made reasonably comfortable and welcome by the townspeople; the wealth of many of the captives also gave a much-needed boost to the local economy. Even so there were men who, as in all wars, are unwilling to see out the conflict or await an exchange of prisoners at some unspecified time in the future, and escapes were attempted. On 17 February 1806, Joseph Allemes, captain of the privateer *Hirondelle*, escaped but was recaptured the following month in London, and as punishment was sent to the prison hulks at Chatham. Young Francis Guieu, son of the cook of the *Alexandre*, ran away in September 1809 after three years in Wincanton 'on account of the ill-usage from his father ... he is now again admitted on Parole'. Francis was finally released and repatriated on 7 May 1810.

On 25 June 1808, the French merchantman *Tigre* was captured and an army surgeon, Jost Duval, was taken prisoner. It was recorded in the Wincanton parole register in January 1810 that he was received on transfer from Tiverton because 'one of the Townspeople there fearing he would seduce his daughter'. Six months later the lusty Jost is reported to have escaped from Wincanton, and there is no record of his recapture. Perhaps he made it back to France with the assistance of local smugglers, and was one of the prisoners mentioned in the following newspaper report in August 1811:

> George Culliford, a notorious smuggler, has been committee to Ilchester jail, for conveying from Wincanton, several of the French prisoners of war from that Depot. Culliford is said to be one of the gang that for some time has infested the neighbourhood, and been aiding the escape of the prisoners from Wincanton to the Dorsetshire coast, whence they have been conveyed to Cherbourg, and it was with great difficulty and perseverance he was taken in consequence of a large reward.

On 3 March 1809, the *Western Flying Post* reported that:

> Friday se'nnight one of the French Officers on parole at Wincanton was found dead in a field near his lodgings; a musket was lying beside him, the muzzle of which it is supposed he had placed in his mouth, moved the trigger with his foot, and blew out his brains. His connections in France are said to be respectable, but not hearing from them as usual, it caused a depression of spirits, which terminated as above described. – Coroner's verdict, 'Lunacy'.

The final departure of the Frenchmen was very sudden. One day in February 1812 a troop of cavalry clattered into Wincanton and surrounded the prisoners at their morning roll call. The troopers were followed by a company of infantry, and it seems that this was so unexpected that the prisoners were completely unprepared to move. The Frenchmen were isolated from the townspeople, and by 4 p.m. they had gone. The prisoners were marched to Mere where they were kept in the church under guard all night, and the following day were dispersed to quarters in Kelso, Hawick, Biggar and Jedburgh to await eventual exchange for British prisoners of war. The Wincanton Burial Registers show that seventeen Frenchmen remained behind in the parish churchyard, the final resting place of Pierre Jacquet and Jean Baptist Fioupe and the unnamed officer who took his life in February 1809.

A Strange Encounter

On 7 May 1828 the *Taunton Courier* wrote:

Some years since a very strange, unaccountable circumstance happened in the White Hart Inn in this town [Taunton]; one of those occurrences that puzzle the philosopher, and strengthen superstition in weak minds. Three or four gentlemen of the neighbourhood were drinking wine in one of the rooms, when the landlord of the inn (as it appeared to them) walked into the room, and coming up to the

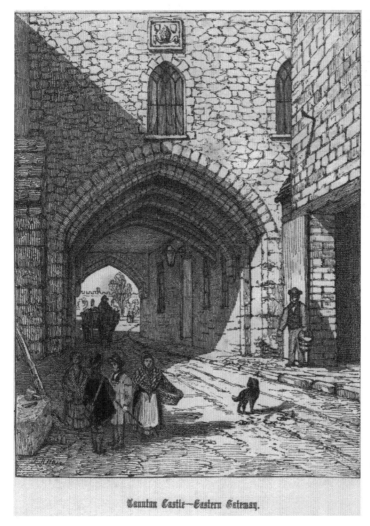

Taunton Castle—Eastern Gateway.

The eastern entrance to Taunton Castle was a familiar landmark in 1828.

table around which they were seated, they addressed him with 'Mr. Baldwin, how do you do? Sit down and take a glass of wine with us.' But instead of doing as they requested, the supposed innkeeper walked out of the room without making any reply, which not only surprised but offended the company, who rang the bell violently, and on the waiter's appearance, they ordered him to send in his master. The waiter informed them that his master was not at home. The gentlemen replied that he was at home a few minutes since, and therefore they insisted on seeing him; but the man assured them they were mistaken, as his master was in Bristol, and had been there several days. They then ordered the waiter to send in Mrs. Baldwin who immediately appearing, the gentlemen asked her where Mr. Baldwin was, and she informed them, as the waiter had done, that he was in Bristol, and had been there for several days, on which the gentlemen grew very angry, and swore that Mr. Baldwin had just come in the room, and on requesting him to partake of their wine, had insulted them by going out of the room without deigning to give them an answer. Mrs. Baldwin then drew out of her pocket a letter she had received from Mr. Baldwin, by which it was apparent that he really was in Bristol. The story was told around the neighbourhood, and all the old women concluded that Mr. Baldwin must be dead, and that he died the very instant that the gentlemen saw him come into the room, but Mr. Baldwin returning two days after, rendered it necessary for them to vary their story. They then asserted that it was a token on some warning of his death, and had no doubt that it would very soon happen. It was generally thought that Mr. Baldwin was weak enough to pay such attention to the story and the inference as to hurt his health, as he really died within a year after, and the old women were not a little pleased at the event, as it tended to justify the truth of their prediction.

References and Sources

Introduction
Somerset Year Book 1928, The Society of Somerset Folk.
A Great Escape
Bath Chronicle and Weekly Gazette, 9 April and 9 July 1835.
Western Flying Post, 18 May 1835.
The Great Storm of 1903
Bath Chronicle, 17 and 27 September 1903.
Taunton Courier, 10 and 16 September 1903.
Western Daily Press, 12 and 29 September and 1 October 1903.
Poor Betty Trump
Jack W. Sweet, *Shocking Somerset Murders of the Nineteenth Century,* Somerset Books (1997 and reprint 2000).
Fatal Water Attractions
Taunton Courier, 28 August 1895.
Western Gazette, 6 August 1926.
Random Tales
See newspapers quoted in the text. J. W. Sweet, Unpublished papers.
Lighting a Pipe (Fatally)
Western Gazette, 2 December 2010.
The Lost Aeronaut
Bristol Times and Mirror, 21 July 1849.
Taunton Courier, 18 and 25 July and 1 August 1849.
St Paul's Church, Kewstoke, burial records.
The Fire at Mill Lane
Western Gazette, 30 April 1909.
Two Very Bad Lads
J. W. Sweet, *Shocking & Surprising Somerset Stories,* Somerset Books, (1999)
Hanging the Nempnett Killers
Taunton Courier, 30 April 1851.
Up and Over
J. W. Sweet, Unpublished papers.
Disgraceful Football
Western Gazette, 27 April 2000.
Poaching and Other Activities
Western Gazette, July 1860, December 1865, December 1894 and August 1901.
Robbery at Wedmore
Taunton Courier, 21 May and 13 August 1845.
Bath Chronicle, 14 August 1845.
In Brief
See newspapers quoted in the text.
Lost in the Snow
Taunton Courier, 1 April 1891.

Dangerous Skies
Western Gazette, 23 May 1913 and 30 November 1945.
The Brighter Cary Club
The Somerset Year Book 1926.
I'll Be Even with Thee!
Jack W. Sweet, *Shocking Somerset Murders of the Nineteenth Century*, Somerset Books (1997 and reprint 2000).
A Gang of Burglars
Sherborne Mercury, 25 November 1843 and 6 January 1844.
Fatal Tracks
Western Flying Post, 26 December 1846.
Western Gazette, 26 April 1901.
Pleased to Remember the Fifth of November
Taunton Courier, 14 November 1866.
Bodysnatchers
Taunton Courier, 5 April 1826, 11 and 18 March 1829.
A Sensational Capture in Bath
The Morning Post, 14 April 1896.
Bath Chronicle, 16 April 1896.
Tragedy at Pen Mill Station
J. W. Sweet, *Shocking & Surprising Somerset Stories*, Somerset Books (1999).
In the Workhouse
J. W. Sweet, *South Somerset News and Views*, December 1995, April and June 1998.
A Loving Epitaph and a Dreadful Murder
J. W. Sweet, *Shocking Somerset Murders of the Nineteenth Century*, Somerset Books (1997 and reprint 2000).
A Slippery Tall Story
Western Gazette, 11 June 2006.
Down on the Farm
Taunton Courier, 15 November 1826 and 9 May 1827.
Western Flying Post, August 1831.
Sherborne Mercury, 10 and 17 November 1857.
Fatal Foods
J. W. Sweet, Private Papers.
A Few Municipal Moments
Taunton Courier, 21 December 1898.
J. W. Sweet, Unpublished papers.
Boating Tragedies
Taunton Courier, 8 July 1829 and 5 August, 1840.
Bristol Mirror, 11 July 1829.
Bath Chronicle, 16 July 1829 and 13 August 1840.
A Fatal Trap Accident
Western Gazette, August 1891.
Crime in Ilminster
Taunton Courier, 30 January 1817 and 6 June 1934.
Theft, Forgery and Fraud
Bristol Mirror, 14 September 1811 and 21 August 1819.
Taunton Courier, 4 July 1811, 19 and 26 August 1819 and 16 September 1819.

Bath Chronicle, 28 August and 9 September 1819.
Jack W. Sweet, *More Shocking and Surprising Stories,* Somerset Books (2002)
A Dastardly Outrage
J. W. Sweet, *Shocking & Surprising Somerset Stories,* Somerset Books (1999)
Lion Kills Man
Bristol Mirror, 17 February 1817.
Bristol Mercury, 19 February 1817.
The Death of a Royal Marine
J. W. Sweet, *More Shocking and Surprising Somerset Stories.* Somerset Books (2002)
Air Raids and a Mystery
Western Gazette, 27 October 1944.
J. W. Sweet, Private Papers.
Church Stories
Western Gazette, 9 January 1874 and 4 March 1870.
Western Flying Post, February and 19 June 1866, *Taunton Courier,* 31 January 1827.
J. W. Sweet, Unpublished papers.
A Death by Fighting
Bath Chronicle, 16 May and 15 August 1839.
A Mayor's Shocking Death
Western Gazette, 26 January 1916.
Drunk In Charge of a Steamroller
Western Gazette, April 2011.
Strange But True
Wells Journal, 10 February 1855.
Frome Times, 31 May 1865.
Pulman's Weekly News, 3 December 1865.
Western Gazette, 29 June 1866.
A Boxing Match
Western Gazette, 20 July 1911.
The Foul River Yeo
Western Chronicle, 21 October 1887 and 13 January 1888.
Surprising Weather
Western Gazette, November 1883, November 1894, January 1932 and February 1978.
Napoleon's Men
Western Gazette, March 2006.
A Strange Encounter
Taunton Courier, 7 May 1828.

Acknowledgements

My great appreciation and thanks to Emma Slee, the editor of the *Western Gazette*, for permission to use the articles from the *Western Gazette* in this book. And a very special thanks to Margaret, my wife and patient supporter through the many years I have travelled back into Somerset's past.

All the images used in this publication are from the author's private collection. Every effort has been made to contact the copyright holders. Please get in touch via Amberley Publishing if you are aware of any omissions, which will be rectified in any future editions.

About the Author

Jack Sweet was born in Yeovil and has lived most of his life in the town and county of many of his ancestors. An old boy of the former Yeovil School, he joined the staff of the Yeovil Borough Council on leaving the Royal Air Force in 1958. After working as a professional local government administrator, he took early retirement following thirty-four years' service with the Borough Council and its successor, the South Somerset District Council.

Jack has a great love of history and for many years has been writing articles for local publications, including the former *Yeovil Times* and the *Western Gazette*. In 1997 his first book, *Shocking Somerset Murders of the Nineteenth Century*, was published by Somerset Books, followed in 1999 by *Shocking and Surprising Somerset Stories* and *More Shocking and Surprising Stories* in 2002, both under the Somerset Books title. In 2002 Jack and Robin Ansell compiled *Yeovil Then and Now* under the Tempus title, reprinted in 2009 by The History Press. Again with Robin Ansell, this time under Amberley Publishing, he compiled *Yeovil Through Time* in 2009 and with Robin in 2015, the *Yeovil History Tour*. Jack's recent books under the Amberley Publishing title are *Yeovil's Years*, 2010, *Somerset Tales Shocking and Surprising*, 2011, and *Yeovil Memories*, 2012. In 2014 Fonthill Media published *Yeovil in the Great War 1914–18*.

In addition to his writing, Jack's interests include local and family history. Inspired by his late father, military history has been a long-lasting passion and in pursuit of which he has visited many former battlefields from South Africa to the Crimea, via the United States of America and north-west Europe.

He is married to Margaret and they have three daughters, two grandsons and a granddaughter.